D0534083

969 3100
To Renew Books
PHONE (925) ~~266-2223~~

Painting from the Source

Painting from

Aviva Gold with Elena Oumano

the Source

Awakening the Artist's Soul in Everyone

 HarperPerennial
A Division of HarperCollinsPublishers

FIRST EDITION

Designed by Stephanie Tevonian

Library of Congress Cataloging-in-Publication Data

Gold, Aviva.
 Painting from the source / Aviva Gold with Elena Oumano. — 1st ed.
 p. cm.
 ISBN 0–06–095272–5
 1. Painting—Technique. 2. Painters—Psychology. I. Oumano,
Elena. II. Title.
ND1500.G59 1998
751.4—dc21 97-50342

98 99 00 01 02 ❖/RRD 10 9 8 7 6 5 4 3 2 1

To my best teachers, my sons
Sabin, Max, and Josh Gershweir

Contents

Acknowledgments . **xi**

Imagine

Imagine the Magic Source . 3
Imagine the Magic Materials . 39
Imagine the Magic Space . 55

Painting

Explore, Experiment, and Play . 83
Deepening Your Experience . 119

The Source in Your Life

Completing Your Painting . 167
Your Ongoing Source Connection . 185

Appendix . 215
Suggested Reading List . 218

ix

Acknowledgments

irst I am grateful to my wonderful writer, Elena Oumano, who transformed the hundreds of pages of material I gave her into a book. Thanks to Stefanie Woodbridge, writer and editor, who helped with the original concept for this book in 1990. I am grateful to the late Suzanne Lipsett, who wrote my very successful book proposal. Thanks to my literary agents, Barbara Lowenstein and Madeleine Morel, who were able to envision the merit of my creative work and of this book. And thanks to Victoria Sullivan, who first told my agents about my work. Thanks to my friend, writer Meredith Gould, for listening and networking in the early stages. Thanks to my editors, Joëlle Delbourgo and Megan Newman, and their assistants, Leigh Ann Sackrider and Hillary Epstein, who were always helpful and who treated me with tact and patience when I behaved like an overly anxious new mother. Thanks too to Laura A. Starrett, for an excellent and thorough job of copyediting, and to designer Stephanie Tevonian, for the look of the book. Next, my thanks

go to my friend Paul Block, writer, editor, and computer expert, for all the hours of assistance in every aspect of this undertaking. Many thanks also to all my friends and assistants who listened, read, and helped, including George Herrick-Lasua, Barbara Edison, Rozanne Hauser, Beth Ames Swartz, Marilyn Simon, Diane Allene, Dawn Silvernail, and Deborah Singletary. Thanks to Gary Schwartz, who invited me to do my first workshop in Asheville, North Carolina, in 1985. A special thanks to my brother Marc Goldblatt, whose support, enthusiasm, advice, and interest meant a lot to me. And to Marc and his wife, my sister-in-law Karen Goldblatt, for allowing me to stay and write the last few chapters in their home in sunny Arizona. Last, my thanks go to my many painting friends and workshop assistants and participants without whom there would have been no inspiration, and no book. You reinforced my trust in the process. I love you all.

Elena Oumano would like to thank Madeleine Morel, Barbara Lowenstein, and Megan Newman.

Imagine the Source Magic

Imagine yourself
painting with no hesitations, no conflicts.

Your brush dips into pots of vibrantly colored paint; inner inspiration guides your hand as it forms lines and shapes that find their perfect places on the paper.

Shades and hues mix themselves, images come forward, take on greater definition, and then recede, painted over and perhaps lost, or coming together again and emerging anew in their own ideal arrangement. You see the painting, feel it, perhaps even faster than your hands can execute it. The painting—not your mind—tells you what it needs. Your brushstrokes fall into rhythm with your heartbeat and breath as you and the painting dance together in an improvised, natural duet. You are confident, grounded, and facile in your own authentic means of expression, whether that expression takes the form of abstract splatters, geometric shapes, or recognizable images. The tensions and pressures of work, home, and relationships are far away; you are lost in enjoying the moment, in the delicious sensations of paint flowing on paper, in the images you are birthing through your painting.

A glowing orange figure wants an ear here, a nose there. A purple and pink mountainside rises against a violet-black night sky. A crystalline turquoise river appears; above it float silver stars and a pale yellow crescent moon.

Your skill increases as you paint. Figures appear out of their need to be present and your own passionate involvement. Ah, there's a

magenta tree and below it roots are sprouting from your brush tip. "Thicker!" they call to you. Like a devoted mother nursing her hungry infant, you submit to the painting's needs. A window appears in a gnarled tree trunk. What? Yes, it is a surprise, but delightful! The window must be there. You have to obey.

As you breathe life into the raw materials of paper and paint, you grow increasingly excited and revitalized. The paint and paper seem to know just what they want to become, and you are the channel for this vision. The pace picks up now, the energy building as you connect even more deeply to the painting unfolding before you and through you, and it takes on even greater life.

Details begin to find their places: tiny green dewdrops here, golden specks of pollen there, the fine fringe of an eyelash, the stiff, precise hairs of a blue horse's mane. You are patient, painting in these details with a loving caress, knowing that this stage of your process promises healing riches and joy, no matter how long it takes. You are committed to the painting, to staying with it until the final detail says, "I'm finished, satiated." When that happens, you will know.

The painting seems complete, but you will settle for nothing less than its fullest life, so you scan it thoroughly, and your gaze is drawn to the dark entrance of a mountain cave in the lower middle section. Oh, yes, of course! That spot awaits a fire's glow and warmth. You

paint in miniature flames—a tongue of yellow-orange-gold, a flicker of blue-violet-red—and then the tiniest figure, an old woman with long, silver hair sitting by a fire. Few viewers would take the time to notice her, but you know she is there, and, with a tear in your eye, you realize that she is exactly right and that the painting is now complete. It radiates a life of its own, and anyone who sees it will sense the magic and joy of that completeness.

Three hours have passed like three minutes. A deep thirst has been quenched—until the next time, when your thirst returns.

You love the painting that has flowed through you. You recognize that it is stunning. Aware of both the painting's significance and your own sense of gratitude and awe at having channeled it, you are amazed yet at peace, deeply satisfied and energized. Like a good parent responsible for launching a child into the world, you regard your creation with a sense of stewardship, not ownership. You may want to share your painting with the world, but without inflated self-importance, without the need for praise or recognition. You may even sense that the painting itself wants to be seen and experienced by others. Or your painting could be private, a personal talisman, a power symbol that will continue to release deeper and deeper levels of your creativity.

Yet, you already have an inkling of what your next painting will

embody, of how it must begin. Its seed comes from the ripened fruit of the painting you've just completed. Each of your paintings tells the story of your personal experience, the urges of your soul, your increasing capacity for sensuous enjoyment and for plumbing the repository of images that all human beings share in common. This repository is like a river that runs through you and around you, a river in which you are completely at home. This river is the *source*. And you have been painting from the source, which is how I describe a universal creative process that returns you to your natural state of oneness with the Divine Creator.

Imagine being so rooted in that creative source, in that overwhelming sense of oneness, that not even an unwelcome critical reaction could move you from the truth of what you paint. Do you lack this deep connection with your creativity? Do you sense how glorious this source connection could be and how much it could enrich your life? The method I will describe in this book will place you firmly on the path to your own creative flow, to awakening your artist's soul, and becoming your own authentic self.

What Is the Source?

The short answer to this question is, "You already know." The source goes by countless names and has many faces and all are true. Native Americans call it Great Spirit. Mystics and seekers throughout the ages referred to it as the Divine. Yogis think of it as Prana, life-force energy.

For our purposes, the source is all that and more—a combination of what Freud termed the unconscious, Jung called the collective unconscious, most modern psychotherapists label the psyche, and psychotherapists/spiritual seekers James Hillman and Thomas Moore refer to as the soul. The source is also what many people call God/Goddess. It contains the deepest stuff of the universe, that part of life and creation that inspires myth, but that remains the great mystery and thus, thankfully, defies precise definition. Actually, the source can only be described according to how it shows its face—and that is everywhere and whenever possible.

I imagine the source as the energy that first set the universe in motion and tossed this fiery molten rock we call earth away from our sun. It is the spark through which the tiniest speck of DNA evolved from a single-cell protozoan into the complexity of us—body, mind, and soul.

The source is also that deepest part of you, the part that remembers everything with absolute clarity. It is the body intelligence that exists without words and recalls past lives, your time in the womb, and your birth. As the collective memory of the creation of the universe and the history of evolution, the source is also home to the primordial imagery of myth, dreams, and remembrances: being a furry mammal in a tree, a bird soaring through the air, a fish swimming in the depths of the sea, a lizard, a seed, a cell in a tidal pool, a crystalline shape, water, molten rock, black holes . . . the explosion that jolted the universe into motion.

The entire universe is the body of the source, and so we ourselves manifest universal source energy, which recycles and evolves as our bodies themselves transmute through death into dust and then rebirth.

The source infuses the Creation that we humans reenact whenever we ourselves create. The source is chaos within order, order within chaos, constant change and flux. It is itself the process of evolution. The source demonstrates its sounds and logic through music, myth, and song; its movement through dance and athletic skill. Poetry and literature are its speech. And images—painting, color, and sculpture— are its many portraits.

The source follows its own rules, which we call paradox. The source is the same for all of us, yet it is experienced uniquely by each of

us. Unfathomable in its awesomeness and simplicity, the source is all-encompassing energy, love, and soul. This is the energy we merge with as we paint: When we create, we are at one with the source. Finally, the source is that indefinable ingredient, that unknown quantity or quality that distinguishes a neatly arranged, aesthetically composed painting from a painting that is a true gift of magic.

Lost and Found

Creativity is supposed to be easy, fun, enriching, life-confirming, and joyous, with no anxiety about end results. The conflict-free creative experience I described in this chapter's opening pages is natural, the way it's "supposed to be." But many of us are cut off from that effortless expression. That's where this book comes in, to restore that creative joy and ease by guiding you through your first "breakthrough" painting to the source.

As young children, we naturally played—perhaps painted—in this body-centered, rapturous state. We were full of our true selves in an innocent way. But as we moved through childhood, our patriarchal, industrial culture alienated and distanced us from nature's rhythms and cycles. The intellect, which we so worship, gradually took precedence over the needs of our bodies and our feelings, which were increasingly ignored. It became harder to play freely, to enjoy ourselves with

abandon, and to tap into our intuitive, self-healing abilities—our source energy. Many of us are estranged from this creative source. Except for isolated moments, we experience varying degrees of difficulty in recovering that spontaneous creativity and the exhilaration and deep satisfaction it brings to our lives.

Our culture and education system also brainwash us into believing that painting is open only to a handful of uniquely talented individuals worthy of the title "artist." Yet indigenous peoples all over the world understand that every human being is an artist. In Bali, the same word means both "human" and "artist," and making art is as much a part of everyday life as planting rice.

While it is true that some people are born with greater manual dexterity and/or a heightened sensitivity to rhythm, design, and color, in the last few decades, we have begun to realize that all of us can create in this playful, blissful, healthy way. Your abilities may be dormant right now, but they can be reawakened and reconnected to the source at any time.

Even if you have forgotten the source experience of your childhood, your body remembers and knows how to take you back. Source energy still lives within you and around you, and is the "place" from which you can create, dream, and live each day in harmony and balance. These words you're reading are merely reminding you of what

you already know: Give yourself free reign and don't be afraid of making "mistakes" or embarrassing yourself. Your path back may involve working through layers of emotional blocks. Reconnecting to the source may recall the pain—for a fleeting moment or two—of your original separation. But liberating your body and spirit for authentic expression is well worth any effort because of the many benefits it will bring to your day-to-day life. Even if you are absolutely convinced that you lack even a shred of artistic ability, just "show up" and face the blank sheet of paper, start painting, and, sooner or later, you will tap into the source.

If you then go on to create from that depth for an hour or two daily or weekly, you will discover that regular doses of painting from the source will actually make you a healthier, happier, more confident person. You may even find yourself behaving differently, acting from a new philosophy of living that makes more sense and brings you what we all want—greater effectiveness and pleasure. Every area of your life—work, relationships, play—will begin to feel fuller, richer, and more satisfying. Whenever you allow yourself spontaneous and uncensored expression—whether through song, dance, music, or any other creative outlet—you make contact with the inner spark that revitalizes every part of you. Your smile, skin, eyes—your entire countenance—come alive. Something seems to switch on at a cellular

level, and you actually glow. You may even notice positive changes—
some subtle, some dramatic—in your physical health. As you know,
body, mind, and spirit are one.

After you have been painting from the source for a while, you will
also notice another amazing phenomenon: Everything that surrounds
you, every person and event that crosses your path, seems to join
this painting process in bringing you more enjoyment, understanding,
harmony, and the inner peace that comes with the realization that
you belong to something greater than your individual self. You paint
daily or weekly, then go about your daily routine feeling more centered,
more enthusiastic. And, yes, if a greater experience of your sexuality
is needed to awaken and balance you, you will find that motor purring
as well. Creativity and sexuality spring from the same energy source,
so, in that sense, they are interchangeable. Too often, we engage
in compulsive sexual activity rather than exploring that same energy
through its "softer" channel of creative expression, while, for some of
us, the opposite is true. So if you are uncomfortable with your creativity
or your sexuality, painting from the source can help you balance your
energy and fulfill your individual expressive needs. And even if you
are relatively content with life, who couldn't benefit from a mood tune-
up from time to time?

Painting and Dreaming

When you lay your head on your pillow at night, you have no idea what characters, images, and plots your psyche will conjure up for your dreams. It's the same when you paint from the source. When you face that blank sheet of paper, ready and willing to paint in this unplanned, uncensored way, you can't predict what images and colors will appear. And there is a special, more aware dream state that parallels the source painting experience even more closely.

Have you ever been aware that you were dreaming at the same time that you were in the dream? If so, you may have realized that you could do anything in that dream. You could win at any sport, surf the mightiest wave, fly through the air, indulge in lusty sex with anyone without guilt, vanquish your nightmare prosecutors and even receive a gift from them. You experienced all this as if the dream events were occurring in real, waking life.

If this description sounds familiar, you were "lucid dreaming." Many books and articles teach people how to perfect lucid dreaming because experts believe that lucid dreaming is enormously beneficial. It is even personally transformative, in much the same way that source painting empowers and enlivens you.

Dream images represent your uncensored internal ideas about

yourself, and dream action mirrors your way of interacting with yourself, others, and your environment. In many ways, this is also true of your source paintings. The images in your paintings express who you think you are, who you really are, and how you relate to your environment. Just as lucid dreaming enables you to change the images of your dreams in order to change yourself, source paintings allow you to alter your self-concepts and your beliefs about the world.

The Senoi people in Malaysia regard dreams as a valuable pool of information on every aspect of their lives—from building and decorating to working out difficult relationships. In fact, virtually all their daily activities are simply realizations of their dreams. For the Senoi, nighttime dreams and daytime fulfillment of those dreams are virtually indistinguishable. They create daily from "dream instructions," and they are considered by anthropologists to be among the healthiest, happiest, and most balanced human beings in the world.

Those of you who already practice lucid dreaming will find source painting is an additional technique to help you become more accomplished, peaceful, zestful, and self-confident. And if you haven't experrienced lucid dreaming or never even remember your dreams, source painting can enhance your dream recall. It also offers a crucial bonus: While a dream is ephemeral, it fades away with the rising sun, a painting from the source experience produces a dynamic piece of

creation that radiates its own authentic energy. That painting is a tangible gift from the source for you to savor and contemplate, enjoy and share with others, whenever you wish.

What Exactly Is Painting from the Source?

I want to pause here to point out that in this book the phrase "painting from the source" has dual meanings. First, it is my way of describing a deep, unselfconscious involvement in the universal creative process. You can write, dance, sculpt or cook, make love, or devise a business plan from the source. Whatever you're doing, whenever you're completely involved in your creative process, you're in the source flow. To my mind, there is no question that whenever you create in this fully engaged, organic, body-centered way—in an altered state that's something like a completely awake dream state—you are within the source flow, in union with the God/Goddess.

I also use these same four words, "painting from the source," to refer to the method I use to pilot people through their maiden painting voyage to their "breakthrough" trip back to the source, perhaps their first experience since childhood. You, too, will take that voyage, by following the guidelines I will set out for you—from the first stroke of your paintbrush, through total creative engagement, to completion of a painting from the source. So "painting from the source" is both my

16

name for an age-old creative experience and a simple method to recover your natural creativity.

Source Language

When you paint in this way, you're dealing with the primary language of the psyche and the source: image. That is why I began this book with the word *imagine* and asked you to visualize yourself painting from the source. Nothing exists in our world that is not first imagined, and the power of image cannot be overvalued. People have even helped themselves heal from serious disease simply by focusing on images of healing. We can't actually see this world of images that lives within us, yet it is entirely real, with its own laws and intentions. That is why we appreciate the integrity and self-determination of the images that surface in our dreams and in our paintings. So our source paintings are literal at the same time that they are symbolic.

My First Breakthrough Back to the Source

Let me tell you how I recovered the rapturous absorption in creativity that I'd known only in the play and painting of my early childhood. I was one of those children rescued by imagination and natural creativity from a dysfunctional and unaware family. I also suffered from dyslexia and the then-pervasive societal message,

reinforced within my family, that females were second-class citizens. In school, the rest of my class did their lessons, while I sat in the back of the room drawing. My classmates' appreciation of my drawings was my only source of pride and pleasure. When I wasn't making art, I felt very alone, helpless, and frightened. Like the ugly duckling in the children's fable, I was always waiting for my real family to claim me and take me home. Sound familiar?

My paintings—my productions—were fussed over and coveted by my parents, whose own creativity was repressed and who offered opinions on what my paintings should look like. A painting I made at age eleven was shown in a children's exhibit at the Museum of Modern Art—a hard act to follow. I was sent to art school, and then to a high school for the arts, where whatever excitement and pleasure I still enjoyed in painting was steadily leached away by formal training, pressures to conform, and regular critiques. The confidence and resilience needed to use formal training to enhance my inner visions was lacking, as is true for so many women in the visual arts.

Education took me down many paths, but they all led to rigid art-world standards. As I grew up and continued working along the lines deemed "acceptable" within the conventional art world, I drifted completely away from the exhilaration and deep satisfaction I'd experienced from art as a child. The more acceptable I became, the

18

more I secretly yearned for that early bliss, when nothing separated me from the paintings that unrolled beneath my brush as imagery and color rushed out unimpeded.

I grew up convinced that my worth as a person depended upon the "great" paintings I must produce. At the same time, I was cut off from my authentic spiritual flow. I achieved superficial success in art school, college, and graduate school, from sales, shows, teaching art to children and adults, and from studying art therapy. But I rarely reconnected with that unfettered creativity of my early childhood. I spent most of my life caught up in the conflict of yearning for, yet fearing, that profound connection. I displaced my powerful inner need with an addictive and futile search for Prince Charming, a culturally approved diversion from my real quest, which was to recover my authentic self and the euphoric sense of wholeness that comes from genuine creativity.

Inevitably, in the midst of a life that appeared to be blessed by personal and professional success, the crisis peaked. I was trapped in a lie and could no longer live without the transforming truth of my true creativity. Then I stumbled serendipitously, as humans in crisis often do, into an entirely new way of painting—freer by far than the painting technique of a trained adult artist, yet in its teachings and healing powers, much more than the painting play of a child.

Fifteen years ago, after trying many programs to reawaken my

creativity, I arrived at a well-known growth center for a five-day workshop in painting naturally. I did not make that workshop easy for those good teachers or myself. With the clarity of hindsight, I now realize that my resistance was comically classic.

My first two and half days at the workshop were murder, as I painted myself into genuine misery. At first, being set loose in a room with all those delicious colors and large sheets of blank paper was thrilling. "A piece of cake for me! I'm right in my element! I'll show them!" The first hour was especially fun, playing with paint again, my reliably facile painter's touch on display. But very soon, "the great artist" was shot down. Under my own hands, my familiar lush abstract landscapes turned to mud. I looked around at the old-timers in the workshop and cringed. Their paintings looked crude, unashamedly raw, even jarring. "This isn't art!" I thought. "I don't know what it is!"

One woman unrolled a large painting in progress that had expanded onto many sheets of paper. She continued working on the tiny details, hundreds of tears falling from the eyes of a roughly rendered mother with a child on her lap. The painting hung in my view, offending me and making me uneasy. I would never paint such a scene. Later I realized this painting touched a painful sense memory of unbearable isolation and helplessness sitting on the lap of my distant mother. Also I was annoyed at the leader's insistence that we finish

20

one painting completely before going on to the next. I ignored her directions. I used many sheets of paper and began many paintings. Yet I hated everything I did. This free spirit, this accepting therapist I thought I had become, resented each and every person and painting in the place.

The headache that had begun on the first day intensified on the second. I couldn't paint anything that mattered. Even worse was the nagging fear that I hadn't expressed anything because there was nothing that really mattered inside me. Again, hindsight sheds some light on my struggle.

I was paralyzed by my lifelong investment in my self-image as an artist and my fantasies about greatness. Better to keep believing that my creative magic was locked inside somewhere than to paint from my true self—whatever that was—and discover that I had no magic after all. Even if I discovered that my magic was real, owning it would mean I'd have to give up that familiar feeling of longing. I was used to that feeling. It was a no-win situation.

I took another sheet of paper and painted a fish. It was okay. Then, on yet another sheet, I painted an old favorite: a scallop shell resting on the sand near the surf . . . hmmmm, "a gift from the sea." Blue-green, salty waves washed over the sand and onto the shell, reminding me of when I had painted the mysteries of the sea twenty years earlier in

graduate school. This water filled with sea life stirred something in me. Suddenly, just when I thought I was finished, I saw traces of a woman's face in the scallop shell. What to do? Struggle. Not the least of my blocks was snobbism, a false sense of superiority. I felt trapped in dissonance. What would my art professors say about this? All those years, money, and effort studying every aspect of art: anatomy, life drawing, aesthetics, color design theory and technique, ancient to modern art history. How could I throw all that away and paint as if those years of study hadn't happened? That would be a waste, completely illogical and self-defeating.

My heart beating faster, I painted the woman's face in the scallop shell anyway. Her shoulders, outstretched arms, and breasts appeared in the sea. Her nipples were pink starfish. Something long dormant began to awaken in me, long-forgotten childhood paintings of mermaids. To the objective, art-trained eye, this was a mediocre painting, nothing to turn anyone's head. As I painted the finishing stroke, I allowed the disapproval I'd internalized from my family and teachers to wash over me for a few moments. Then that disapproval began to ebb away, and the image of what I must paint welled up in its place. This woman-in-the-sea painting was the bridge to my next one, my breakthrough painting to the source.

I dipped my brush into bright magenta paint and boldly filled a

new sheet of paper with the large, squatting figure of a birthing woman. With no concern for the correctness of her anatomy, I showed her ample hands holding a newborn girl just emerged from her oversized vagina. As the African mask–like face of the mother gazed down at the infant with the bonding force of passionate, unconditional love, milky drops fell from her breasts into the infant's open mouth. Holding back nothing, I painted a heart in the chests of each, mother and child, and a dazzling nimbus of energy radiating from their bodies. Then, something prompted me to paint in opposite corners a green crescent moon and a red sun enclosed in a red circle—my newfound signature. Finally, I painted an umbilical cord attached to a heart-shaped placenta.

I was in ecstasy. Nothing else mattered but this painting. My entire being knew I was home. I felt the sweetness of reconnecting with a soulmate after many lifetimes of separation. I doubted if there was anything else left in me to paint. I didn't realize it then, but I know now that I had painted my version of God/Goddess/Creation—the mother I had longed for to adore my newborn self, as well as the mother I had become in birthing my own creativity. In doing so, I had empowered myself greatly. "I could die right now and be satisfied," I sighed contentedly. Yet at the very instant of this painting's completion, I became fascinated by the prospect of yet another painting. I knew what it would be and how I would paint it.

23

Within a very short time, I began to see that this new way of perceiving and painting did more than restore depth and spontaneity to my work: It was a force for positive life change in countless ways. For the first time I understood the meaning of the word *transformation*. Each painting offered me the opportunity to confront and resolve an inner conflict, fear, or other deep issue, including, to my surprise, health problems. As these conflicts, fears, and issues came to life as images in my paintings, I was able to recognize and resolve them, and that healing touched and enhanced every aspect of my life. It seemed as if all my senses heightened and became more sensitive, as though I now perceived the world around me through a multitude of channels. I became more open, bolder, and self-confident. My anxiety attacks disappeared, along with the aches and pains of arthritis at the completion of a particularly intense painting. Tapping into my creative source made me feel more worthwhile, so I began eating better and exercising more. My "voltage" soared. I developed new personal style and flair. I felt more attractive and sensual, and I began to view others in a more generous and compassionate light. Life's obstacles, great or small, no longer intimidated and paralyzed me because I began to trust myself and the universe. I now knew that whatever fate presented to me, I would make the most of it.

Thus began the series of openings and self-discoveries through

painting that has led me to share my experiences with you. Facing that blank sheet of paper and moving my paintbrush across it without plans or restrictions allowed a lifetime's worth of misbeliefs and blocks concerning painting—and life—to finally surface and express themselves. In order to be really real, to feel truly alive, I had to confront those issues about being unprofessional, ignorant, empty, childish, mediocre, worthless, and appearing that way to everyone else. I had to acknowledge and release my spite, that is, I had to let go of wanting to stay entrenched in my unhappiness so I wouldn't have to let my family—and even God—off the hook for the sin of abandoning me. I had to stop holding them hostage for my unhappiness. I had to let go of my fears of being competitive and envious, as well as my fears of being the target of someone else's envy. I had to let go of the fear that something bad would happen to me or to my family, particularly my mother, if I were to live fully, sensuously, and be truly creative. I had to release the fear of being alone, isolated, crazy, and excessive. And I even had to say good-bye to the fear of being connected and whole. Images of the many illusions and beliefs that had sustained and bolstered, while simultaneously suffocating me, appeared in my paintings in order to say that they had been living within me and now wished to go. In their place came new engagement in life, a greater sense of fun, and the certainty that I was fine and complete all on my own, just as

Imagine the Magic Source

I am, without anyone else's approval or praise. I can now see how yesterday's wounds have prepared me for today's triumphs and teachings.

..

Can you identify with my story or any part of it?

There are many paths to greater health, happiness, emotional stability, and spiritual evolution, and probably thousands of practices that foster personal integration. I know firsthand, having searched out and sampled many of them. You probably have, too. And yet here is something else I know through long and fruitful personal experience: No path or practice is quite so powerful, quite so immediate in its potential to enliven and heal, as putting brush to paper and painting with your entire body and soul.

Painting is an ancient means through which we have attempted to unravel the mysteries of existence for many centuries. It's as old as the petroglyphs and cave pictures that call to us across time and space. This painting ritual has always been with us, yet each of us must seek it anew for ourselves.

Does painting from the source attract you? Does the description you read in these opening pages feel at all familiar? Have you tapped into the source accidentally, unexpectedly, at some time in your past? Do you yearn to experience this intense, delectable, and liberating

experience regularly? Do you long for a fuller, more vibrant, and pleasure-filled life? Better, more honest, and supportive relationships? More confidence? More free time to relax and nurture yourself? Do you want to care for your body, mind, and soul through this powerful creative—and spiritual—practice? Then stay with me. This book will be your guide.

...

After that first breakthrough painting, I found myself unable to paint anything but images of women with their legs splayed, birthing all sorts of creatures—scaled serpents, feathered birds, furry mammals, and strange humanoid creatures—in every imaginable setting—still woodland ponds, the dark depths of the sea, verdant jungles, the vastness of outer space. But after the exhilaration of that first breakthrough painting wore off, I began feeling embarrassed and concerned about the meaning of all this weird fecundity. What was wrong with me? I couldn't help myself. So I kept painting, hoping the meaning would reveal itself. In fact, I made the decision to trust that meaning was there and that, somehow, I would find it.

Little by little, it began to dawn on me that I was painting God the Mother. I knew absolutely nothing then about the goddess and wild woman archetypes that are so popular today. But I did know that as I painted, I felt increasingly powerful and free.

I remembered being a small girl, sitting in the balcony of the Orthodox Jewish temple with the other girls and women, gazing down at the men in the privileged seats below. We females couldn't sit with the men. We couldn't touch the sacred Torah. We couldn't be near the rabbi or the cantor. We certainly couldn't *be* the rabbi or the cantor. I recalled how I felt, like a second-class citizen—inferior, insubstantial, and incomplete. Now I had painted myself as I truly was, as much an image of the Divine as anyone else. For the first time, I felt the spiritual and emotional bond that, as a child, I had been taught I didn't deserve. I no longer needed anyone else in order to feel complete, valid, and loved by God.

You don't have to be in trouble, as I was, to desire this healthful reconnection. All of us yearn for a greater sense of belonging and meaning in our lives. Painting in this intuitive, noncensoring, explorative, and engrossing way gives us that profound and healing connection, as well as a heightened ability to simply enjoy our world. The sense of mastery, awe, and aliveness you receive from authentic creative activity also gives you a larger, more accurate picture of life, death, and our eternal souls.

What Happens When You Reach the Source?

Allow me to make a point I'll remind you of over and over again in this book: Everyone is unique and the path to the source will be different for each of you. Some of you have been painting from the source intuitively your entire lives. For you, this book will be a confirmation. Others of you may have been longing to connect with the source. You might do it in one reading, in one hour, or after you've read a single sentence of this book. It could take a year of painting to make that authentic connection. But you will feel honest and alive every step of the way.

Your first few breakthrough paintings may strike you as "ugly" in the conventional sense, but they will be genuine and, therefore, truly beautiful. Aspects of your personality that you've brushed aside or ignored completely may appear as images in your painting; in fact, those hidden aspects will inevitably emerge at some point or another during this process. Painting from the source involves "cleansing phases" in which those suppressed parts emerge in your painting in order to be recognized. How could it be otherwise? Reaching for the source means you must be as honest as possible, acknowledging and reconciling yourself to personal traits with which you may be uncomfortable, at least initially. If we are to become whole, authentic

human beings in love with life and ourselves, we must learn to accept and integrate all aspects of ourselves.

Even the parts of yourself that you find most unappealing, destructive, or even shameful possess a kernel of positivity that is liberated whenever you express those "negative" parts through creative activity. What you previously considered negative becomes a positive force in your life. It's the same as the necessity of embracing the beauty within the beast in order for the beast to be liberated.

Once I made my connection to the source and gave life to my inner goddesses and demons through painting, my life smoothed out and began to flow more easily. My money situation improved, and I was able to buy my house in the country. I began doing work that I loved and truly believed in. My health problems actually disappeared, and life in general grew sweeter and much more fun. Of course, being human means facing ever new challenges and getting upset at times, so I can not offer a guarantee that painting from the source will waft you away to a nirvana of permanent bliss. I can, however, state with confidence that once you establish painting from the source in your life, you will spend less time panicking over any problems that arise because you will come to view these trying situations as opportunities for you to evolve.

Your Unique Source Connection

Everyone has a unique creative inner landscape of personal themes and images, a specific way of seeing and painting, of imaging and rendering as individual as one's fingerprint. When Picasso was in his nineties, he painted himself as a very young painter, with all the hopes, magic, and innocent beauty of a boy artist. That portrait, in all its newness and wonder, was Picasso's lifelong guiding image, a picture of his authentic inner self.

The imagery within you is virtually limitless. We might even call it a holograph of our universe, a vast array of inner pictures drawn from our world that materialize when you need them and that are framed from your authentic and unique perspective.

Devorah, a striking African-American woman in her early forties, hadn't painted since third grade when she arrived at one of my painting from the source workshops. She had studied drama at a New York City high school and earned a college degree in communications. After working as an executive secretary, Devorah had been handling publicity for a long-running Broadway musical for four years. She liked her job, but for a long time she had felt ready to move on, that this work was not really her own. Finally, after a heated argument with the person who had hired her, Devorah quit. She consulted her astrology chart,

which advised her to break free of old restraints and engage her creativity. A week later, Devorah turned up at my workshop.

"I can't paint like the rest of you artists," she told the group at the first sharing session. "I can't even draw a stick figure." The first day, she called me over to evaluate virtually every brushstroke. My suggestion that she paint whatever she saw on the paper without censoring it struck her as revelatory. At the same time, my advice seemed like something she'd always known. Gradually, a picnic scene peopled by African-American adults and children unfolded, a scene reminiscent of Haitian folk art. As her painting moved further and further from the constraints of ordinary reality, Devorah called me over repeatedly for reassurance. "Oooh! Come quick! I painted a fish in the sky! Is something wrong with me?" she asked, only half-kidding. "This is art," I told her and the rest of the group. "And you can take artistic license. We have cameras for exact reproductions."

When the majestic figure of a woman in a colorful ceremonial robe appeared in her painting, Devorah gasped. "This is a continuation of the last painting I did in third grade," she exclaimed. "Everyone made such a fuss over it that I became frightened, and I never picked up a paintbrush until today."

Devorah went on to paint in many workshops and even to assist me. She also painted in her unique folk style every day, producing

32

scenes from her life and her dreams. Her paintings are allegories, touchingly authentic in their child's innocence and wise woman's depth of soul. Devorah even shows and sells her paintings, and she recently started a business to support other artists in getting their visions out into the world.

Allison's experience with her childhood art had been completely different. During an art session in second grade, her teacher handed Allison a page torn from a coloring book and said, "Since you can't draw, color in this picture." The rest of the class was allowed to be more creative. From that time on, Allison was terrified of art and pursued only scientific fields of study.

After one brief Painting from the Source introductory workshop, Allison was overcome by a powerful urge to rediscover her creativity. Despite many obstacles, she managed to find time for a week-long painting session. Allison was also a runner and, seven months earlier, she had injured her ankle. One and a half months before the workshop, she underwent corrective surgery. Unable to run for a long time, Allison sensed that anger and fear had built up inside her because she couldn't "run it out." But she didn't realize how much pent-up emotion she was carrying until she experienced the wonderful release of "painting ugly." For those of us stuck on perfection, superficial beauty, and being charming, producing a messy, ugly painting and learning to

appreciate its raw beauty and galvanizing energy is a major act of personal liberation.

"I wanted to make something pretty," Allison told me after the session, "something I could be proud of, that would prove I really could draw." But as she allowed herself to let go, dark and frightening images had appeared on the paper. At times, she complained to me that she felt lightheaded, and each time she returned to her painting after a break, she had difficulty recognizing it as her own production. At the end of the workshop, she told everyone, "I believe I was painting with another part of my consciousness," and she shared with the group a description of the pent-up feelings she had released. "My ankle is still healing, so I didn't get the 'miracle cure' I was wishing for," she told me later. "But I feel a sense of calm and trust in the universe that I had just about forgotten during this past year of hardships." By embracing her "darker" energies, Allison was able to broaden her repertoire in subsequent paintings and include "lighter" energies.

Like many people who come to my workshops, Allison had to paint what she thought was ugly in order to get past her self-limiting ideas of perfectionism and her inhibitions about not being creative and talented enough to paint a "beautiful picture" that others would admire.

Andrea, an intense professional painter in her mid-thirties, had no problem "painting ugly." She came to the first of the many painting

from the source workshops she's attended since more than eight years ago. Despite her training in the arts, occasional shows and sales, and daily painting sessions of several hours, she never felt accepted or legitimatized by the art world. Andrea struck me as the Janis Joplin of painting: Her images were primitive, raw, intense, and wild almost to the point of madness. She was unconditionally plugged in and allowed powerful unconscious dream imagery to appear unabridged in her paintings. But Andrea felt lonely and ostracized, by the professional art world and by family and friends. She attributed her isolation to this uninhibited aspect of her work and her personality.

At her first painting workshop, Andrea met kindred spirits who were respectful of and comfortable with her. Feeling at home for the first time, Andrea wept with relief. She began to experience her work as healthy and herself as completely sane.

In subsequent workshops, Andrea delved even deeper into her soul. As she felt increasingly accepted by herself and others, her paintings became even more authentic and versatile, imbued with a new aura of wisdom and sparkle, at the same time retaining their original, compelling vitality. The energy Andrea had used to protect herself from self-doubt and inner conflict was now free to channel itself into creative flow and sensuous enjoyment. Greens and violets found their way into her paintings where before there were only blacks and olives. Playful,

humorous figures full of grace showed up to interact with the deformed, violent, raw, and tormented ones.

Time to Awaken Your Artist's Soul

All you have to do to make your own personal source connection is simply ask this ever-present energy to wrap you up and deliver your body and soul to the larger, freer space where you should be. Just show up in a safe place with a paintbrush in your hand and the intention to stay with the process. The paintings you create from the source will become, in turn, windows to the source—living records of your experience, of *you*—for you to contemplate, live with, enjoy, learn from, and return to, again and again.

Within this creative dimension, the adage "timing is everything" takes on new meaning. Yet time follows its own laws. Once we learn that we can't control time, we let go of trying, and allow time to work for us. In other words, however long it takes you to start painting from the source is the amount of time you need to get started.

Some people who come to my workshops pick up the phone to call me as soon as they spot my advertisement in a magazine or workshop center. Sometimes all they may have seen is the title, "Painting from the Source." They barely ask questions, even about the cost. "This is just what I am looking for," they tell me, or "The description woke up

something. Sign me up. I can hardly wait." Others receive my mailings and hear of the workshops from their friends for years before they're ready. Some even sign up and cancel several times until they actually come. Chances are that if this book has fallen into your hands and you have read this far, you are ready.

What brings all of us to this place of desire, of awakening, of telling ourselves, "I must paint," stems from a fundamental urge to expand, to experience our lives more fully and authentically. Many of us are restricted by our own unexamined, often nonconscious prohibitions against pleasure, play, and other "nonproductive" activities. Some pundits in our society condemn creative pursuits for their own sake as frivolous or even sinful. But we know better.

In the cases of Devorah, Allison, and Andrea, an external force in the form of a life crisis brought them to their "edge" and stimulated the desire for this transformational and soul-expanding painting experience. For Devorah, it was quitting her job. For Allison, it was an injury that prevented her from "running out" her emotions. For Andrea, it was a recent rejection by an art gallery. But you don't need a crisis to bring you to painting from the source. For many of you, the need to paint commences with a quiet prompting of the soul. For some, painting is simply a well-planned event that has been awaiting the discharge of responsibilities so that you can savor this creative

experience fully. Whatever your reasons for immersing yourself in this liberating and expanding painting process, everyone seems to sense that whenever you do say yes to genuine creative experience, you are also saying yes to the alluring possibilities of new life . . . you are saying yes to the awakening of your artist's soul.

Imagine the Magic Materials

Imagine the perfect raw materials right at your fingertips:

magine the perfect
raw materials right at your fingertips:

39

smooth sheets of pure white paper, pots of vividly colored tempera paints, and soft, full-bodied brushes. These are the very same materials with which you painted so freely and happily when you were a child, and they're still encoded with that freedom, intuition, excitement, and spontaneity. The most soul-touching, transformative paintings often spring from the humblest of materials.

Walking into an art supply store or paging through an art supply mail order catalog can be daunting, confusing, and anxiety-producing, even if you're trained in the arts. Do I need this? How expensive does it have to be? Even the most eager painter can become overwhelmed and discouraged by the voluminous variety of drawing and painting materials (various types of paint, crayons, pencils, charcoal), as well as the many different brands, qualities, and prices, and the choices of surfaces on which to apply these media (paper, canvas, boards), not to mention the different tools (brushes, knives, and pens). Big business plays on the need to do things "right," that is, the way the "art elite" does them, and promotes the myth that the more dazzling, tricky, and expensive the media used to make a painting, the more unique and artistic it will be.

We won't give in to marketplace pressures, and we are demystifying once and for all the illusion that the art elite controls our definition of

what makes for important art. In painting from the source, the process of painting and the joys of that experience are paramount. We emphasize opening ourselves to the source and expanding our capacity for truth and happiness, so we are not distracted or inhibited by fancy, expensive materials. We do not fall for the pervasive lie that if we use just the right media, we will be more inspired and our work will look particularly good. In fact, we don't even care about looking good.

Whether you go out to shop for materials or order them from home, stay relaxed and casual, and avoid the trap of art elitism. Tempera paint, paper, and brushes—these are your ideal materials, and they're all you need. These materials are inexpensive, easy to use, nontoxic, biodegradable, and magical.

Why Use Paint?

Anyone who has ever used paint can tell you that unlike drawing materials, or even wet clay, paint combines the sensuousness of liquid motion and the excitement of color, along with tantalizing possibilities of unplanned, spontaneous blendings. The colors stimulate you, while the fluid movement lulls you into a mild trance that melts away blocks to inspiration. Moving paint on paper, whether with your hands or a brush, stimulates your emotions and intuition, helps you surrender control, and puts you in touch with your powerful inner imagery.

Even simple colors can move you deeply with their opulent textures and subtly different vibrational tones. They can even give you an appreciation of the exquisiteness and expressive power of "ugly."

Why Tempera Paint?

Those of you who remember easel painting in kindergarten have already used tempera paints (sometimes called poster paints), although they were probably overwatered and drippy. Your teacher probably bought them in powder form and, to make them stretch, added too much water. What makes tempera especially perfect for painting from the source are those associations with childhood's freedom and fun, its nonarchival and nonpermanent quality, its wide availability, and its inexpensiveness. Tempera paint is also very versatile. It comes from the store in a thick, opaque form, but you can water it down as you wish. It dries quickly and can be painted over easily again and again, especially after the layers below have dried. Tempera is also nontoxic, and, in most cases, it will not stain clothes, floors, or furniture, and washes out easily with simple soap and water. In other words, tempera is perfect for a "freedom experience."

For our purposes, it's easier to buy tempera paint in liquid form—thick and ready to use in a variety of bright colors, in pint-, quart-, or gallon-size jars. (Some jars are equipped with pumps for easier

dispensing.) Tempera is inexpensive: A quart ranges from $5 to $8, depending on the brand. Brands differ mainly in the density of the whites and yellows. The white and yellow of more expensive brands are denser and cover darker hues more easily, but you can increase the density of cheaper brands by adding powdered white and yellow.

One of the many delights of the painting process is mixing colors. Tempera paint comes in at least twelve rich colors: white, yellow, peach, orange, red, magenta (a purple-red also known as fuchsia), purple, blue, turquoise, green, black, and brown. It mixes easily in containers, on a "palette" (in my case, a plastic dinner plate with molded sections), or on the painting itself—accidentally or on purpose, it doesn't matter—to make dozens of other colors and shades. I always premix eight additional colors in separate empty jars with squirt tops: pink, gold-orange, dark red, lavender, light blue, light green, beige, and gray.

When you mix your own colors, use much more of the lighter color and just a small amount of the darker, since dark pigment overpowers light. Pink, for instance, is made from mixing approximately four parts white with one part red; powder blue comes from mixing four parts white to one part blue. I make a dark oxblood with red and just a dab of black; gold-orange with yellow and orange; lavender with white and purple; yellow-green with yellow and green; light brown or beige with brown, white, and a touch of yellow; and gray with white and a

drop or two of black. Experiment with mixing and you might discover a new color—*your* color.

I suggest you buy the following colors: one quart-size jar (or the equivalent in pint-size containers) each of peach, orange, magenta, violet, blue, green, turquoise, brown; two quarts each of black and red; four quarts each of yellow and white. As you may have realized, you will need to buy extra white and yellow paint for mixing additional colors. After you've been painting for a while, you'll develop a sense of your individual color needs and buy accordingly. You may also want to get extra plastic pump bottles and/or small flip-top plastic containers for storing the colors you mix. As with all materials, it is easier and less expensive if you can order in bulk.

About arrangement of colors: In art school we were taught to lay out the colors on our palette following the order of the colors in the rainbow—yellow, orange, red, violet, blue, green, with white preceding the yellow and black following the green. I like that, probably because it follows the way in which nature presents colors to us in the sky or the way light shines through a crystal. And, if you mix colors yourself, you will probably find this arrangement easiest and pleasing, but you're free to arrange your colors in any order that you like.

You can use a spoon or a brush to transfer paints from their containers onto the palette or directly onto the paper. You can also pour

paint or squirt it from plastic squirt bottles directly onto your palette. The key is to remember that even the tiniest amount of a dark color on your brush, spoon, or finger will turn light colors like white or yellow into gray. The same thing will happen if you don't wash your brush well after using a dark color or if you don't change your cleaning water after it's been colored even slightly with dark pigments. And if you don't have enough space to spread out all your colors, each with its own spoon, use spoons only in the light colors of your setup and wash your brush well every time you change from dark to light colors. You may also want to have an absorbent rag or paper towel handy so you can wipe brushes before and after you rinse them in the water. Keep in mind that turning your colors dark may be what needs to happen: There are no mistakes, no accidents in painting from the source, but it's good to have information that allows you the option of preserving your light colors. Don't worry if you forget: You'll learn all of this on your own by trial and error.

Your magic media also includes the spontaneously inspired natural substances this painting process welcomes, like bugs that have serendipitously kamikazed into paintings. Unplanned, unexpected inclusions are inspired and authentic, as integral to this organic painting process as the images you create with paint and brush.

Ellie, a woman in her mid-thirties who attended one of my

workshops, was undergoing a major life transition and questioning her true identity. In the midst of deep engrossment in her painting process, she quietly picked up the scissors and began snipping away, not at her painting but at her long hair. The first person to notice the pile of hair accumulating on the floor under Ellie's painting literally screamed in shock. We all turned to look on, astounded, as Ellie painted the pile of hair on the floor bright orange, then glued it onto her painting to make a powerful, primitive, synergistic composition.

Again, these additions are not "accidents"; they present themselves as natural—albeit at times a little bizarre—outcomes of deep needs, and they inevitably turn out to be transformative agents for painter and viewer alike.

But don't think about that now. Don't plan. Just trust that the images and colors your hand and heart will coax from the raw materials of paint and paper, and any other ingredients that come along, will inspire you and lead your painting to wherever it wants to go.

Paper

The guidelines used to choose paint also apply when choosing the surface onto which you will apply the paint: Keep it simple, easy, and cheap. I usually use plain white drawing paper of a minimum 80-pound weight. Weight is a way of indicating how thick and durable the paper

is. Heavier papers are more expensive. In your case, you want to ensure that the paper can support many layers of paint without tearing apart. But even thick paper can tear, and if it does, remember that in painting from the source there are no mistakes, no accidents. Be sure not to use paper so thick that you can't roll it easily into a tube or, if your painting wants to grow, attach other papers with masking tape.

A good minimum-size paper to start with is 18 by 24 inches. Many painters begin with double that size, 24 by 36 inches, and still their paintings can grow to five times or more their original size. Your possible choices range from five hundred sheets (a ream) of student-grade 80-pound, 18-by-24, white drawing paper at about $45 (about nine cents per page) to a high-grade, archival, handmade paper of the same size for around $45 per page. It's best to avoid expensive materials, especially in the beginning, as they may intimidate and inhibit you.

Unless you are ordering for many people, you may want to buy your paper in a pad and tear off sheets as you need them. Avoid spiral-bound pads as you might then need to trim the edge where the paper is torn from the pad—unless, of course, the jagged edge becomes part of your process. Try not to spend much more than nine cents per page, so that you won't be worrying about waste.

Besides art supply catalogs and stores, large print shops and

printing supply stores can be an inexpensive source of paper, especially in sizes other than the standard 18-by-24 or 24-by-36 sheets. My own ideal starting size is 20 by 26. Printing supply stores may also have appropriate paper left over from printing jobs that they'll sell for a low price. And for those of you who have plenty of storage space, a large roll from which you cut sheets may be the way to go. For example, you can order a brand-name roll such as Kraft that measures 4-by-200 feet for only $24.

Brushes

While it's important that your medium—tempera paint—and your paper be nonarchival and cheap because they are used in large quantities, the opposite is true of your brushes. Well-cared-for, quality brushes can last a lifetime. Buy watercolor brushes in which the hairs come to a point and are made from sable, squirrel, or equivalent, high-quality, strong hairs. Look for a brush in which the hairs have resilience. The brush should have some spring when you paint; that is, when you lift the wet brush from the paper, it should bounce back instantly to its original shape. Ask the store attendant to bring you a glass of water and paper to test the brush.

Brushes come in sizes ranging from approximately 0 to 16. You need a size 0 for details, a size 8, and a size 14 or 16. Some brushes are

needlessly expensive. Altogether, your three brushes should cost about $25. You may also want a larger brush in case your painting needs to really expand. I have an oval wash brush, as well as one or two $4 brushes from the hardware store for laying in large areas of a color. Sponges also work well for covering large areas.

Take good care of your brushes. Don't do anything that will bend the hairs, such as leaving the brush end standing in the rinse water, making slashing strokes, or pushing the brushes into any surface. If you need to get violent while painting, use the hardware store brushes or your hands. When you pack your brushes for travel, make sure the hairs are protected from bending. Wash your brushes in warm water and a little noncreamed, mild soap. Gently bring them back to their original point shape while they're drying; do not pull on the hairs to draw out excess water.

Of course, you may be inspired to use other tools to apply and move paint, such as sticks, stones, and nails. Then there are the original tools, your hands. Virtually all body parts have been used in this process, including feet, noses, and elbows. I recall going through a necessary and liberating foot-painting phase. In a recent workshop, a middle-aged woman named Janet broke free of a lifetime of inhibition that no longer served her burgeoning free spirit. She surprised and delighted us, and herself, when, after hours of frustrated blockage, she

began painting with her bare nipples. You never know what natural and readily available material or method will appear to liberate your spirit.

At some point in the future, you may even want to make your own paints, paper, and brushes. This could become part of your process. Anything is possible, and source information on how to do that is given in the appendix.

Meanwhile, here is a list of other basics you may need to have on hand:

◆ Two-inch-wide masking tape for attaching papers onto paintings that grow. Tape is also used to attach paintings to the wall or to wall coverings such as newspapers, plastic drop cloths, and wall boards.

◆ Push pins, the easiest way to attach paper to wall boards.

◆ Old newspapers or drop cloths to cover your furniture, floor, or walls (it's easier than cleaning up spills and drips).

◆ A water container to clean your brushes, large enough so that you don't have to change the water too often.

◆ About twenty 2-ounce flip-top or squirt-top containers for all your colors and a shoe box to hold them in for easy portability. An extra squirt bottle can hold water to squirt onto paint on your palette that may be drying.

◆ A large, white plastic dinner plate with three separate molded

sections to use as your palette. You can also use any plate or an ice cube tray.

◆ Plastic wrap to cover your palette and keep your paints moist during short breaks.

◆ Scissors. You never know how small or what shape your painting will need to be.

◆ Glue in stick or liquid form. You never know if pieces of a previous painting or some other element will need to be attached to your painting. (Remember Ellie?)

◆ Extra light bulbs, just in case.

◆ Candles, for atmosphere.

I hesitate even to mention this next material so early on, because I don't want you to think about completing the process at this stage, before you've even begun to paint. But at some point in the future, when you and the painting are certain that it is complete and that the painting wants to be preserved, you can buy a bottle of clear gloss liquid acrylic. When the painting is completely dry, using a soft, oval-shaped wash brush, apply a thin, even coat to your painting. (Then wash your brush immediately with warm water.) The gloss will seal, protect, and bring colors back to shine, as if they were wet again. Make sure before you apply the acrylic that the painting is truly

complete. Once you apply it, acrylic is difficult to paint over with tempera (though you can paint over with acrylic paints).

Painting on the Road

You may be planning a trip to a remote site where it would be difficult to bring an extensive painting setup, but you want to paint on your trip. Of course, you can take your brushes anywhere—they're small and portable. During my treks in Nepal, Bali, and the rain forest of Belize, I trusted that anywhere I went, I would find water and a small container. So I carried a pad in the largest size I could pack and painted using the cardboard backing of the pad as support. I brought a student-grade watercolor set with seven cakes of hard color that cost about $6. The open cover became the palette on which I mixed colors. If you use the colors undiluted straight from the tube, and add white and yellow from small tubes, you can simulate tempura's opaqueness, layering, and overlapping of light over dark. Student-grade tubes of watercolor cost about $6 each. They are tiny and their concentrated pigment goes a long way. You can squeeze the tube contents onto the palette and let the paint dry, then wrap it all up into a neat little package, perfect for travel, and later reliquify the paints by adding water.

If you find yourself unable to use paint for any reason while you're on the road, oil pastels combine soft crayon and pastel to produce an

experience that's like drawing with paint. They come in many nontoxic, inexpensive brands, with Cray-Pas being the best known. A box of twelve nontoxic student-quality oil pastel crayons costs under $5. If you find a source that will sell you colors separately, get a few extra whites, yellows, and whichever other colors you use most. This drawing material allows for almost all the versatility of paint. The colors can be mixed with your fingers, a tissue, or simply by applying one color on top of another. You can also layer light colors over dark, and you can scrape layers of color away. Oil pastel paintings can grow just as watercolor and tempera paintings do—by adding on more sheets of paper. Just make sure you buy a few extra boxes of oil pastels as filling in large areas will wear the crayons down.

..

Those of you who paint daily and possibly earn your living from selling your art and/or are trained in the arts may resist abandoning the media to which you are accustomed. As a trained, professional painter, I empathize with your resistance. Perhaps tempera seems like a step backward. You may be afraid that a moment of brilliance will not be captured permanently or that you cannot afford to waste time painting anything that lacks sales potential. Yet, it may be even more important for you than for painting novices to break your habits and return to your roots of art as play. I suggest that you humble yourself a bit.

Allow yourself to become vulnerable and childlike again, and "unlearn" by experimenting and exploring—at least for a while—with these simple materials. You won't regret it.

Your raw materials of tempera paint, paper, and brushes—even watercolors and oil pastel crayons—are perfect for the process of painting from the source because of their simplicity. *You* are the unknown, creative element that will transform these humble materials into instruments of living magic.

Imagine the Magic space

Imagine
entering a large, well-lit room.

The air is fresh with faint hints of your favorite natural scent. Large rectangular sheets of smooth white paper are tacked to a length of paint-splattered boards that circumscribe the room. Your eyes are drawn to a table on which you see a neatly arranged rainbow of glowing colors in transparent cups. You feast on luscious peach, tangy lemon-yellow, brilliant golden-orange, deep burning orange, soft blushing pink, dark blood-red, hot rose magenta, petal-soft lilac, rich purple, sky blue, deep midnight blue, shimmering turquoise, fresh sap green, velvety dark green, pale beige-brown, warm earth-brown, elegant gray, and the purest black and white.

Other objects on the table attract your attention: bunches of paintbrushes arranged like bouquets in glass jars, one holding brushes of varying sizes, another, smaller jar with tiny brushes used to create the most minute details. Additional jars contain clear water for washing the brushes.

A white plastic spoon rests in front of each cup of paint, and there's a stack of white plastic plates with three separate molded sections. You realize that this smorgasbord of color can be spooned onto your plate-palette like so much mashed potatoes and gravy and that you can mix these delicious colors to create your own tones and shades.

You glance around the spacious, airy room to find something set up to copy, but there's no live model, no vase of flowers, no bowl of

artfully arranged fruit, no print, no picture. Nothing hangs on the walls, not even a sample completed painting. But a small table stands in a far corner, covered by an exotic-looking cloth. It holds a candle, an ancient brass bell, a stone, a crystal, a seashell, and an array of other intriguing objects. Except for this "altar," all you see in the imaginary room are sheets of paper and the long table with its rows of vibrant, rich paints, jars of water, plastic plates, and brushes.

The room is ordered but relaxed, like a child's playroom—the ideal kindergarten playroom, in which you need not be concerned about being neat, about paint dripping onto the walls or floor. The room has been planned carefully to allow for freedom, comfort, and safety, and for fortuitous accidents and messes.

. .

The painting space we just imagined is ideal, not only in its physical aspects but in its ambiance and intention. In fact, my painting from the source workshops are conducted in such spaces. You may already be forming ideas about your own painting space, or how to alter whatever space you have. If you can arrange a space for your painting like the one we've just imagined, wonderful. If not, it really doesn't matter. Your willingness to engage in this painting experience is far more important than the physical specifications of where you paint. You can paint from the source in a tent perched high in the

Himalayas or on a paper that's taped to the refrigerator door in the kitchenette of your one-room basement apartment.

I'm also asking those of you who are professional artists to be open to possible adjustments in your painting space. Some of you may have already incorporated the suggestions I'm making here. If so, my guidelines should be welcome confirmation. For others, it may simply be a matter of shifting your consciousness, of increasing your awareness of the importance of safety and simplicity to your creative expression. The most important consideration is that you approach this opening of your creativity with self-appreciation, compassion, and protection. Rearranging a small detail in your studio could make a big difference in terms of feeling safe and inviting the source to participate more fully in your painting process.

If you do not have a secure, private spot and your children and spouse are underfoot everywhere, tack up that sheet of paper in the kitchen, garage, or bathroom and take out your paint jars (or tiny watercolor set) after everyone's gone to bed or before they arise in the morning. One hour of painting from the source is as refreshing as a few hours of sleep. If your living space is tight, perhaps you have a set of bookshelves, a window, or a door that's not used often. Stand a board or table against that bookshelf, window, or door and you're good to go. Sometimes, all you have to do is move a chest of drawers in one

direction, a hanging mirror or picture in another, a chair to a far corner, and an entire wall has opened up for your painting. And, of course, there's always the floor or the table top.

I have a painting studio in my basement where I also lead small workshops of up to thirteen people. There's enough elbow room for everyone and there's also room for the paintings to grow—sometimes as huge as six feet by six feet, bigger than the painter. I also use that space when I'm alone and painting large. But even though that space is ideal, I like to improvise. Painting from the source stimulates that exploratory spirit. When I'm painting by myself in the warmer months and my painting is small and manageable, I will either hang it on a wall or put it on the floor in my back or front porch. Painting on the floor is a comfortable variation when I'm feeling especially "native." In the winter, if I am alone, I may set up on the floor in front of my fireplace. Sometimes I feel like just taping a paper to the refrigerator door and painting in the kitchen.

I store twenty colors (twelve from the paint company and eight that I've mixed) in small flip-top containers together with a few brushes and a plastic plate–palette in a box in my studio. So I just go downstairs to get the box, fill a container with water, put a paper on the floor or tape it to the refrigerator door, and I'm ready to paint.

It's amazing how resourceful we can be when creativity calls. It

reminds me of the ingenious ways in which young lovers manage to find spots where they can be alone if a house or car is not available. Once, when I was painting with a group in the rain forest of Belize, we decided that our painting room was too tiny and dark. Everyone went outside to find their own location. The sides of buildings began sprouting papers; tables were stood on end and papers tacked to their surfaces. Paintings were created on the ground and on large, flat rocks. When it rained, all twenty of us took to the shelter of a small porch, fit our papers together like pieces of an intricate puzzle, and continued painting.

More Tips for Your Painting Space

◆ If you have a permanent studio, you can attach a piece of construction board such as homosite, plywood, corkboard, or foam core to the wall, particularly if your walls aren't smooth and you'd rather attach the paper with push pins than with masking tape. Since the paintings can get pretty large, push pins hold up a painting that has grown heavy with size and layers of paint more effectively than masking tape will.

◆ If you cannot attach anything to the wall, lean a large panel (using any lightweight material you find at a lumber yard) against the wall and pin or tape your painting to that. When I lived in an apartment in

New York City, I taped plastic drop cloths used for house painting to a wall, attached my paper to that, and placed newspapers on the floor to catch drips. I once rigged a system in which I glued a strip of Velcro to the wall and another on the plastic drop cloth, so that I had zip on-zip off wall protection. When I finally pulled off the glued-on Velcro, I did have to touch up the wall a bit, but that was a minor inconvenience. I have also covered the wall with newspaper sheets and masking tape and then attached my paper. Under proper conditions, masking tape should not remove paint from the wall when you peel it off.

◆ Don't be distracted by worries that you'll spoil your home or your clothes. Tempera washes out easily. It does make cleaning up easier, though, if you cover the floor, table, or anywhere else paint can drip with sheets of plastic or newspaper. You can throw an old shirt, an apron, or anything else over your clothes whenever inspiration calls. Have all of the above on hand. You may be the image of neat, controlled order in your "normal" life, but the source can grab you up and wreak havoc on that order. Who knows? You may have been waiting all your life for that havoc.

◆ Remember, the painting dictates what you do, not the other way around. You may be telling yourself, "I'm not going to let my painting get bigger than I want it to be. Who is in charge here, anyway?" Well, the painting is in charge. It has to become whatever it needs to

be in order to maintain its integrity and help you become a freer and more self-accepting person. So, whenever possible, give the painting room to grow. It may start out on the refrigerator door, move to a wall in the living room, and then across the street to a friend's house because it outgrew your own. If you own an easel, put it aside for a while, as your painting may want to be bigger than an easel can support.

◆ Once you've arranged your paints and mixed the additional colors you want, place them on a surface next to where you paint if you have a permanent spot, or transfer them to smaller containers, such as 2-ounce flip-top plastic cups that you keep ready for easy transport on a tray or in a shoe box.

◆ If you're not painting near a direct source of water, have extra water in your painting space, along with a waste container in which you can dump used water. Whenever you set up your painting materials in a limited space, try to place them within easy reach of your painting hand.

◆ If you're painting at night, be sure that proper lighting is available. Sometimes a good painting spot becomes perfect simply by using a clip-on lamp or an extra-long extension cord, although some people love to paint by candlelight. ◇

Remember, the only real guidelines you need for setting up your painting space are simplicity, safety, and as few distractions as possible.

Safety

In order to take risks while you're painting, you must feel safe, certain that no one will enter that space who could disrupt your painting process. Here are some suggestions to ensure your sense of safety:

◆ Wherever you paint, whether in a private studio, your kitchen or bedroom, make sure that no one who could possibly inhibit you enters that space. This may mean posting a sign on the door or planning your painting time so you won't be interrupted. If others are painting with you in the room, do not look over their shoulders as they paint, and make sure they don't do it to you.

Have you ever noticed how people seem to stop whatever they're doing in order to watch someone draw or paint? It's fascinating for the viewer but inhibiting for the painter, especially if that painter is taking personal risks by expressing his or her most vulnerable aspects on paper.

Even after years of painting and teaching from the source, I notice that my spontaneity disappears if I'm painting under the watchful gaze of people who don't understand my approach. I remember one instance a few years ago, during a visit to friends of my family in Florida. They are artists and are devoted to art, and they encouraged me to

paint in their home. As I painted, I could sense my growing desire to please them, and I just didn't feel totally free. I painted a lovely image of a woman by the seaside, which they loved, framed, and still keep in a central place in their home. I like the painting too, and I'm happy that they treasure it, but I know that both myself and the painting could have reached a more profound and nourishing emotional and spiritual level. I was cut off from that depth of expression because these kindhearted people were acting as my audience.

Yet I am comfortable painting in the presence of my three nonpainting (not yet, anyway!) sons, even if I'm getting "wild" and portraying women with serpents coming out of their vaginas. They may tease me and roll their eyes, but we've gone through so much together as a single-parent family that we don't hide our feelings. And that's the key. I feel freer to reveal myself, to take creative risks, around my sons than I do with some people who paint daily.

◆ Train anyone around you, no matter how comfortable you are with that person, to refrain from making any comments or facial expressions when they do view your painting. Even an approving look or word can feel intrusive and inhibiting. If the people in your life are inspired by your example to take up a brush and paint with you, then you'll all be in the same boat. But make a pact not to reveal any details of each other's painting processes outside your space. And don't "take

"care" of him or her at the expense of taking care of yourself.

◆ Keep a reassuring object or presence in your painting space. It could be a pet, a stuffed animal, an encouraging or comforting phrase or affirmation hanging on the wall, such as "I am contented and at ease while painting" or "Satisfying images and colors flow from me as I paint." It could be a reminder of what you're after: "The truth shall set you free."

◆ Add to the safety of your space by making your painting sacred, thereby acknowledging the deep connection between painting and gifts from the divine, and how this bond opens you to a fuller, more liberating life experience. When you actively transform your painting space into a sacred spot, the source is encouraged to enter your painting. An inviting message goes out to a deep recess of your soul, saying that it is welcome to come out and play and that it will be protected. ◇

You can say a prayer in which you ask for divine energy to flow through you and give you whatever you need. You can set up an altar on which you place any items that have special significance for you—a rock, bone, feather, seashell, religious object, picture of someone you trust and love, or a candle you light each time you paint. If your painting space is shared with other household functions such as cooking and cleaning, place these "sacred" objects in a corner or on top of the

fridge. You can chant or sing a song, ring a bell, beat a drum, or strike a wind chime. You can burn incense or sage or spray the air with a favorite scent. You can perform a dance or make up ritualized movements or meditate. Have fun, get loose, and don't worry about how you would look to others.

Hold the following thoughts in mind—or write them down and post them on the wall—while you paint to keep you feeling safe:

♦You can paint absolutely anything you want in this space, anything your hands, feet, or your nose wants to do, needs to do. You can even paint with your eyes closed.

♦You can use all the paint you want, and take all the time to paint you need.

♦You have no restrictions. You can be as messy as you want, drip paint on the floor, smear paint off the paper and onto your body, mix any colors together, make the paper any size or shape, or hang it in any position. You can do anything your heart desires. You can paint any image, no matter how grotesque, pretty, corny, babyish, silly, or obscene. Paint anything. ◇

Add to the above statements any others that enhance your sense of safety and your willingness to be uninhibited and take risks.

Remember, when you create a safe space with the intention that magic will happen there, creativity rushes in the way air rushes into a

vacuum. There's absolutely no need to get complicated with this. Whatever you do—whether it's making a simple request for guidance or performing an intricate ritual—just make sure that you feel at ease and trustful when you're in your painting space.

Years ago, when I first began to paint in this way, I would say a brief prayer, ring my Tibetan bell, and light a candle. Now the act of picking up my brush is itself the opening prayer. Every room of my home has some sort of altar to hold the objects I've collected from nature during my travels, and I have gradually incorporated into my house the sounds and scents of the woods that surround it. The bottom line is that any spot you come to with an open heart and the intention to go wherever the process takes you is automatically safe.

Distractions

It is important, particularly in the beginning, to choose a place that will encourage you to train your focus inward, a place that will not bombard you with distractions.

Being still with just your inner self for company can be difficult. People can go to comical extremes in order to distract themselves from strong emotions that well up and to put the brakes on complete involvement in their process. I remember one woman in a painting from the source workshop who wore a full bouffant hairstyle in order to hide her Walkman's earphones.

◆ Avoid listening to music while you paint, at least in the beginning, because music exerts a powerful effect—physical, emotional, mental, and spiritual—on your entire system. As you know, music is commonly used to create or break a mood. Even if there are no lyrics, music can take you away from your inner voice or feelings or it can induce emotions other than those you are authentically experiencing at that moment or which may be just below the surface.

We want to allow the act of painting—the sight of the colors, the fluidity of the images—and your in-the-moment emotional and spiritual needs to inspire your painting direction. Music can dilute the purity of your painting journey. Painting in silence, with just the natural sounds of your breathing, the room, and whatever filters in from outdoors, ensures the authenticity and potency of your connection with your inner self, with your painting, and with the source. At a later phase in your painting journey, you will become more sensitive to that connection and better able to suspend self-judgments and allow images and colors to flow from within you. You will sense the direction in which you're headed, and you can even use appropriate music to augment that direction. But exercise caution, because you may need to take a sudden unexpected turn in terms of mood, image, or color, as often happens in your dreams. In time, you will recognize your inner music and may even find yourself wailing your own melodies and lyrics as you paint.

◆ "Going inside" has both literal and metaphorical meanings in painting from the source. Stay indoors when you paint, at least until you are well-connected to the source. Even if you have a private outdoor space, nature offers distractions and temptations: inviting scenes, weather conditions, wind, sun, and the sounds of water, animals, birds, and insects. Even indoors, keep the painting space spartan and simple. Later on, after you have established a solid source connection, you can roam around and choose outdoor painting spaces.

◆ Choose a time to paint when you are least likely to be interrupted. Don't answer the phone. Turn off the ringer and turn down the sound on the answering machine. Your local telephone company offers a silent and inexpensive solution to unwanted interruptions—voicemail service for a few dollars a month.

I have a love-hate relationship with the telephone. I curse it as a distraction and time waster, yet I can't live without it. When I first started painting from the source, I would turn the ringer off, but I could hear the answering machine click on in response to calls and would be overwhelmed by curiosity about who was calling. Maybe the call was presenting the opportunity of a lifetime and I was letting it slip through my fingers by not answering. So I got voicemail service, and I no longer hear a thing, but I'm also less worried about missing anything.

A number of beginner painters in my workshops have found it so

difficult to paint solely from their imagination and feelings that they will go outside to study the woods, peek through a window to copy an interesting vista, or copy a pattern on their clothing or an item on the altar. I try to be loose and flexible about their needs, because I know that eventually they will be able to rely solely on their soul's direction. Even so-called positive and healthy practices such as yoga, meditation, and keeping a journal can distract you from delving into unknown psychic territory, if you use them to interrupt painting during moments when you're experiencing some emotional discomfort. We all know that these are life-enhancing practices, but if they're used to stop you from exploring that discomfort and thereby engaging more deeply in your painting process, they become impediments. In painting from the source, we welcome any uncomfortable feelings that arise while painting, because we know that they are really opportunities to know ourselves better and to resolve any buried issues and conflicts that are holding us back from our true selves. So, if you experience emotional or even physical discomfort, keep painting in order to explore what that feeling looks like on your paper and what it's really about. Once you allow that level of expression, its control over you and its emotional charge dissipate, and you are set free. ◇

Painting with a Group

Painting with others stimulates my unconscious. Seeing the struggles of others, as well as the images they paint, helps me confront my own struggles and find resolution.

—George Herrick-Lasua, visionary painter

If you have a strong calling to paint with a group, keep in mind that it's as much a matter of allowing people to come to you—"Build it and they will come"—as it is a case of you seeking them.

After twelve years of leading painting workshops for thousands of people, I've discovered that no matter how diverse the group, a common theme underlies the communal experience—the desire for creative, spiritual connection. When you paint and share from your heart with others, you allow yourself to be vulnerable. Even if you do not speak about yourself at all, your painting is right out there for you and all the room to see. When you join a painting group, you provide the chance for this deep, precious, honest, authentic expression—your full range of ugliness and beauty, heaven and earth, agony and ecstasy—to be fully seen, heard, acknowledged, accepted, and valued, sometimes for the first time in your entire life.

As you can see, there are advantages in painting with one or more safe persons, especially in the early stages, before you create your breakthrough painting, which is the first painting that dissolves blocks

to your creative source flow (this is addressed in detail in parts two and three). But if group painting is inconvenient, don't give it a thought. This process works just as well for the solitary painter, and the guidance offered in this book more than compensates for the benefits of painting with kindred spirits. However, if you do decide to form a painting group, here are a few key guidelines:

◆ If you have a large studio, you can adjust the space so that you can invite other(s). If you barely have enough space for yourself but still want to paint with a group, look for a large, inexpensive or even free space to which you can invite painting mate(s). It could be a room in a church or school, an empty store front, garage, attic, unused commercial space, the town grange, a community center, the YMCA, or an abandoned factory loft. A For Rent sign may have been posted in front of a nearby building for years. Call the number, the owner might even be amenable to letting you use the space without payment. Or look for a painting buddy who has a large space.

◆ If you already belong to a group, or know of one in your community, such as an Artist's Way or Arts Anonymous group, see if the members would like to add painting from the source to their activities. (See appendix for Artist's Way and Arts Anonymous groups.)

◆ Make sure your painting buddies have read this book and that you feel safe enough to share personal information with them.

72

◆ On the other hand, make sure that you will not have to protect anyone. You're painting to take care of yourself.

◆ Display some of your favorite quotes from the book along the walls of the studio.

◆ Your fellow painters should be at least eighteen years old—if extraordinarily mature, sixteen. And if you are under sixteen yourself and want to paint in this way, more power to you.

◆ Structure your painting group in a democratic fashion. Take turns facilitating each session.

◆ If it's at all possible, include a wide range of ages, life styles, religions, races, and nationalities, as well as men and women.

◆ Have a few volunteers come early to set up the studio for the first meeting, so that when everyone arrives, you can get right down to introductions.

◆ Have everyone introduce him or herself and tell the group why he or she has come to paint.

◆ It's good to begin and close every painting session with a brief prayer or guided meditation and the vow to keep private whatever is painted or spoken in that room during the session. This anonymity ensures that you all feel safe.

◆ If you are painting in a group that includes someone you know well—a spouse, friend, or family member—it's best not to paint near

this person. This can inhibit you in subtle ways. Your whispering with that friend or family member could defuse the anxiety that often catapults you into deeper involvement with your painting process. Flirting or starting a romantic intrigue with a group member can also be a distraction. If a meaningful relationship is meant to develop, try to hold off a bit, until after you've both completed your first breakthrough paintings. At that time, your feelings should be shared with the group. Secrets tend to contaminate the honesty and openness of this process.

◆ Have lots of drinking water (not ice cold) and cups available and encourage everyone to drink a lot.

◆ When you return from breaks and view what you did in the previous session, you may need a brief group witnessing session. But if you're experiencing blocks, it is best to paint them out instead of talking about them at length.

◆ Don't say anything about your own or anyone else's painting during the workshop while the paintings are in the formative stage, even if it's a compliment like, "I like your painting." Any judgment at all, even if it's positive, can provoke a return to inhibition and performance anxiety, that deep need so many of us have to please others and win their approval.

Even observations such as, "Oh, I see a figure in that corner" can feel disruptive to the painter. So it's very important to rein in feedback,

unless the painter specifically asks for it, and to refrain from self-criticism as well. When we do respond to someone else's painting, we follow a specific etiquette, a conscious use of semantics that makes all the difference. We don't assign any labels to someone's painting. Instead, we take responsibility for our own response. "Your painting is exciting (or beautiful or sad)" is not okay. Say instead, "I am touched by your painting; it brings up feelings of elation (or fear or peace) in me." Again, offer these comments only if the painter wants feedback. A number of people in my workshops have specifically stated, "I don't want anyone to say anything about my painting." During sharing/witnessing time, they ask the group to simply say their name, as in "Susan, I see your painting"—this is very simple but very powerful.

◆ If the session is long, have everyone bring a bag lunch or order food in, so you don't have to leave the space for lunch. Lunchtime is also a good chance to share what is going on for you after a few steady hours of morning painting. After lunch, go back to painting.

◆ Close each session with a sharing/witnessing period, in which each person has the opportunity to share.

◆ Before you leave the painting space, set a time when you will meet again. Meeting with the group at least once a week is ideal. If you can't meet that often, take your painting home with you. Continuing

that painting at home alone may be necessary in order to reach that initial breakthrough to the source. You may find yourself rolling up your painting and carrying it back and forth between home and the group space, because it's important to complete one painting before you start another.

◆ After a certain period of time has passed, let's say a few weeks or at the conclusion of a retreat weekend, most people will have completed at least one breakthrough painting. At that time, it's good to devote ten minutes per person for a fuller sharing, which I will describe in more detail in Part 2. ◇

Now, Let Go of Doing It "Right"

The key consideration in all this is to enjoy yourself and go at your own pace. Observe your need for distractions and respect your vulnerabilities with compassion, patience, and a sense of humor.

I want to tell you about a past workshop experience that seems funny today but didn't strike me as humorous at the time. About ten years ago when I was into "doing it right" and definitely more controlling than I am today, I led a workshop at a health and creativity center located on a Greek island. The workshop was what the British term "an alternative vacation" and it included participants from Europe, mainly the United Kingdom. From the moment I arrived,

I found myself forced to divest myself of all plans and rules.

The site was breathtaking, a remote, soulful spot on the edge of the azure-blue Aegean sea. Ancient, spiny volcanic rocks rose up to line a beach cove dotted by grass huts, old stone structures, and outdoor showers and toilets. Goats scaled steep hillsides where tiny, whitewashed one-room chapels perched. Sheltered by fig trees and vines weighed down by colorful gourds, we sat at outdoor wooden tables and feasted on delicious locally grown produce and other natural foods.

But all I could think of was that this gorgeous location made a dismal painting setup. My workshop was one of five being offered at the same time: The participants painted only two hours or so each morning for six days, cramming the sessions in between many other activities. The painting space was that same outdoor dining room, and people taking other courses marched in and out of our space lugging cumbersome wind-surfing equipment, life jackets, and other assorted gear. Their shouts as they played in the sea and the deep belly breaths of the yoga students on the ridge overhead were more than audible. As if all those distractions weren't enough, I had been assured that a good supply of tempera paints and paper would be ready. When I arrived, I found a dusty box filled with spiderwebs and a limited variety of ancient, poor quality, powdered poster colors with mixing

instructions written in Greek, and a roll of waxy butcher paper. And, oh yes, the workshop participants. I had never held a workshop with Europeans before. As they introduced themselves, mostly British in clipped, stately accents as professors, attorneys, and other professionals, they appeared formal, reserved, and inhibited—not at all what I had expected. Have I mentioned yet that our souls manifest the situations we need in order to grow? Well, they certainly do.

I was convinced this would not work. Everything was wrong. I became hysterical, at least on the inside. During the first session, I nearly lost it. The wind-surfing crew stomped through our painting space; people cut vegetables for lunch while chatting and listening to loud music; and my class straggled in late and left whenever they pleased. My composure wore away as I tried to steer what I viewed as a situation rapidly spinning into mayhem. To my extreme shock, my group confronted me about my authoritarianism. Me, the lifelong poster girl for personal freedom. I finally couldn't help but see the humor in this disastrous situation, and that helped me loosen my grip. I was right to protect the group and the process, but my style of doing so was the problem. I was behaving in a grating fashion out of fear. The moral of this story is it's not what you do as much as how you do it.

To make a long story short, despite the many imperfections and distractions, by the end of the week the magic of the source had been

evoked fully. The special stimulation of the atmosphere and the chemistry of the group had led each workshop participant—myself included—to his or her own personal epiphany. People cried, ventilated, shared their deepest secrets, and felt truly liberated. The paintings— the living records of those epiphanies—were awesome. By the second week, the workshop had grown from ten participants to my limit of twenty. I tell this story to you—and to myself—as a reminder that the details of your materials and space are never as important as the intentions of your heart and soul. It really comes down to just showing up at the blank paper willing to open yourself to the process, take risks, and hang in there. Once it's launched, the painting itself will lead you.

PAINTING

aviva

EXPLORE, EXPERI-MENT, AND PLAY

he most important reason for painting from the source is so your inner source—that is, the *real* you—can come out and play.

83

Painting spontaneously and without censor invites you to explore that inner self by allowing its images to find their way into your painting. All the "hidden" aspects of your experience must be recognized and integrated for your "outer" self to manifest and blossom. Trust that your inner self is essentially wise and seeks harmony, fulfillment, honest spiritual connection, and that its natural expression will enhance your life immeasurably. Sounds wonderful, doesn't it? Yet we human beings are funny about change: We tend to resist it, even when the change is positive.

Procrastination

One of my deepest, darkest secrets that I myself discovered only recently is that I'm a painting procrastinator, and the primary reason I lead painting from the source workshops is to ensure that I keep painting. In fact, my resistance to painting is nearly as great as my passion for it. The majority of first-timers in my workshops are also painting procrastinators. Sometimes it takes a few workshops spread over several years for procrastinators to stop making excuses and get down to a regular home painting schedule.

Does this sound familiar? You may remember how much you loved painting when you were a child and you're eager to get started, yet you're having trouble finding the time to paint. In fact, you are amazed

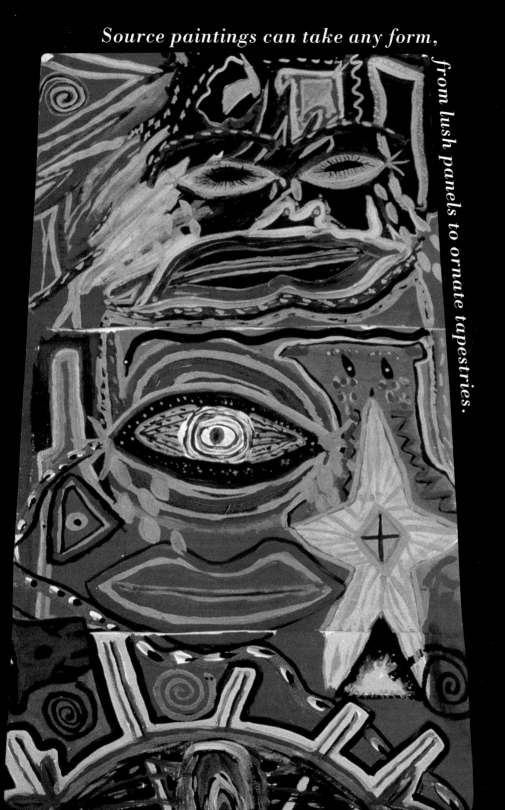

Source paintings can take any form, *from lush panels to ornate tapestries.*

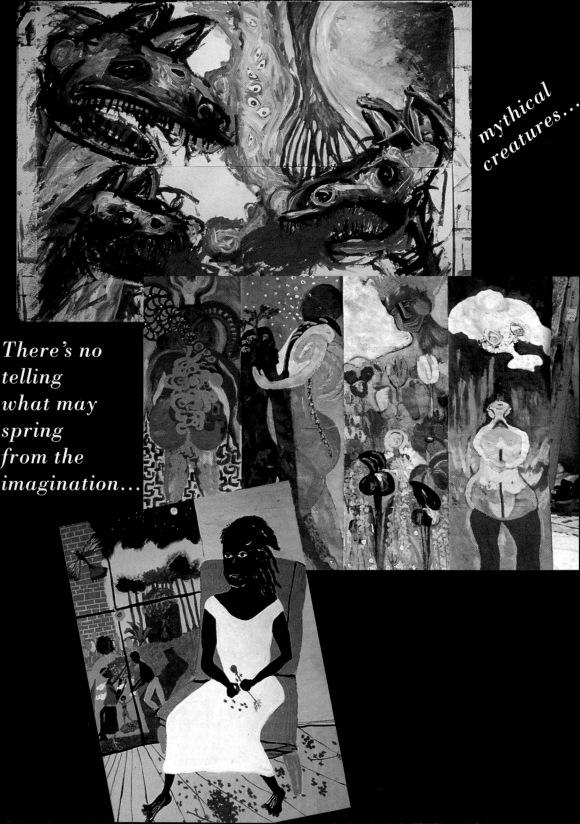

mythical creatures...

There's no telling what may spring from the imagination...

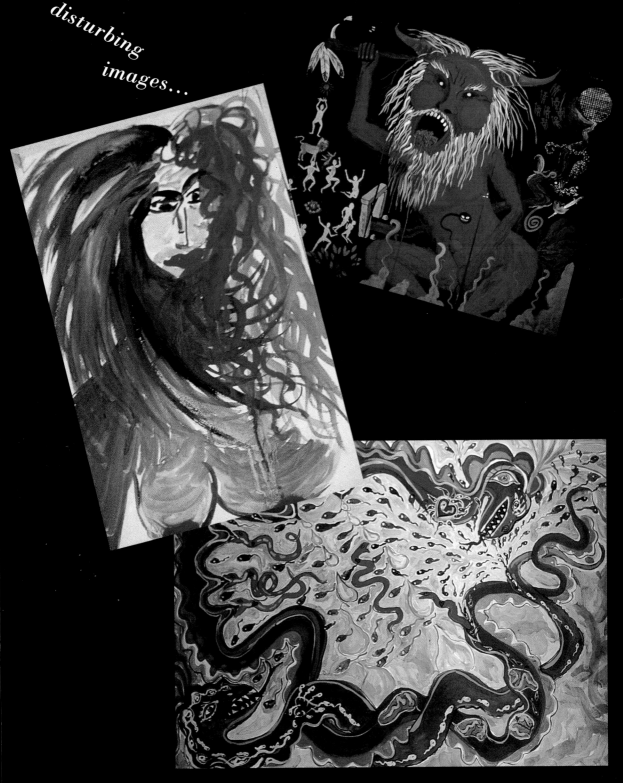

disturbing images...

u n i v e r s a l s y m b o l s .

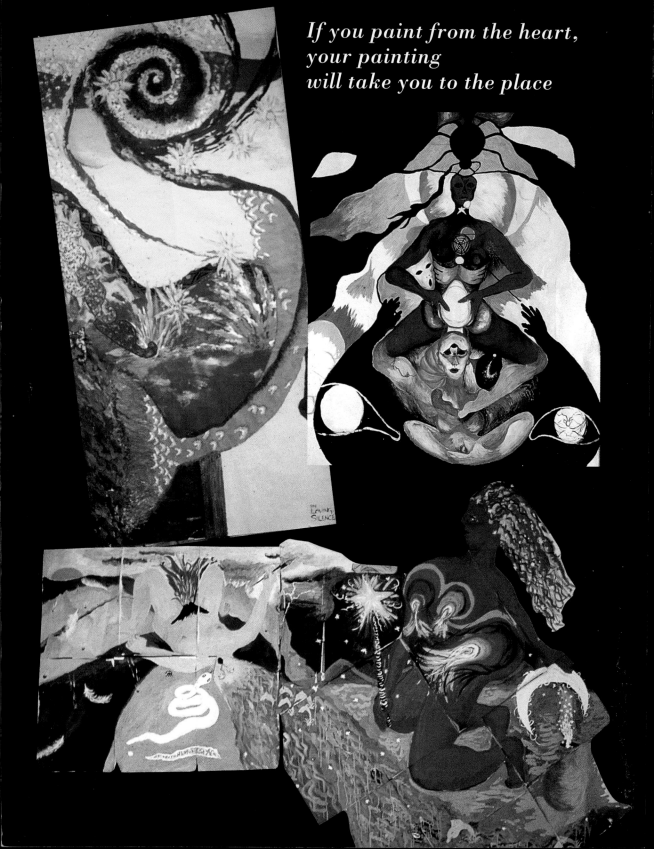

If you paint from the heart,
your painting
will take you to the place

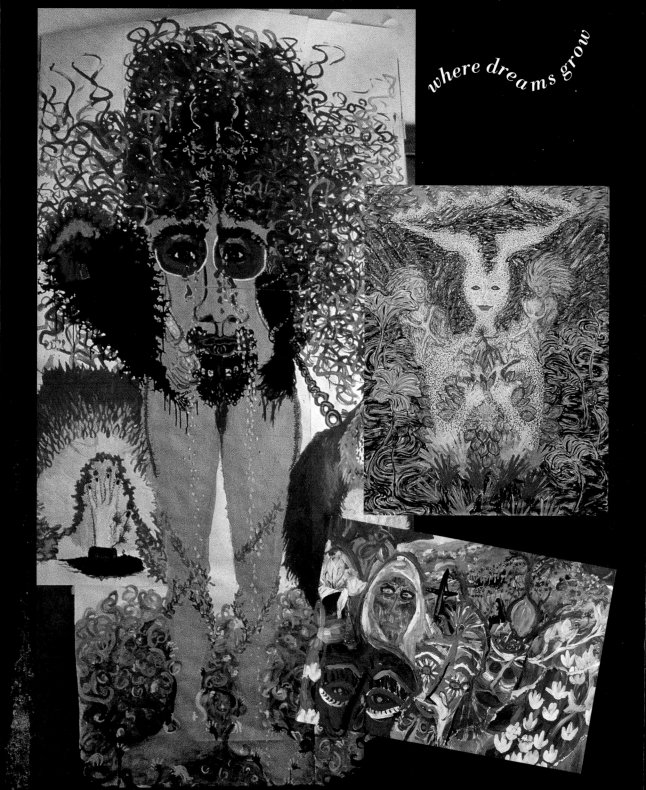

where dreams grow

Watch your paintings evolve…

an unusual shape there…

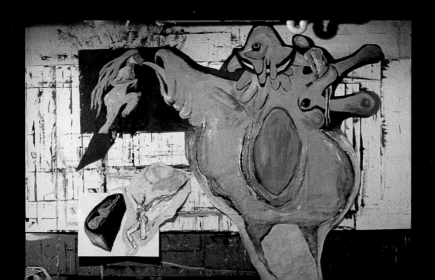

a burst of vivid color here...

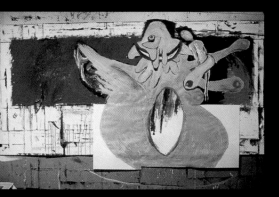
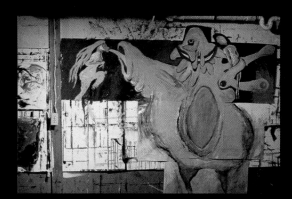

add more paper to each side...

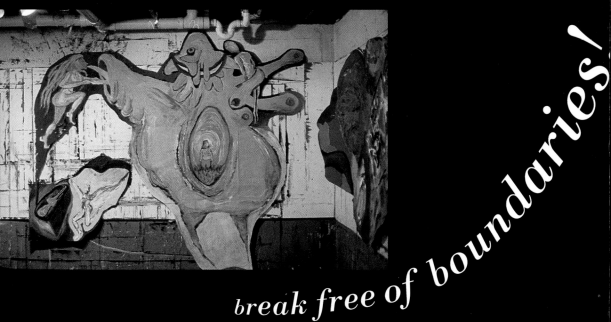

break free of boundaries!

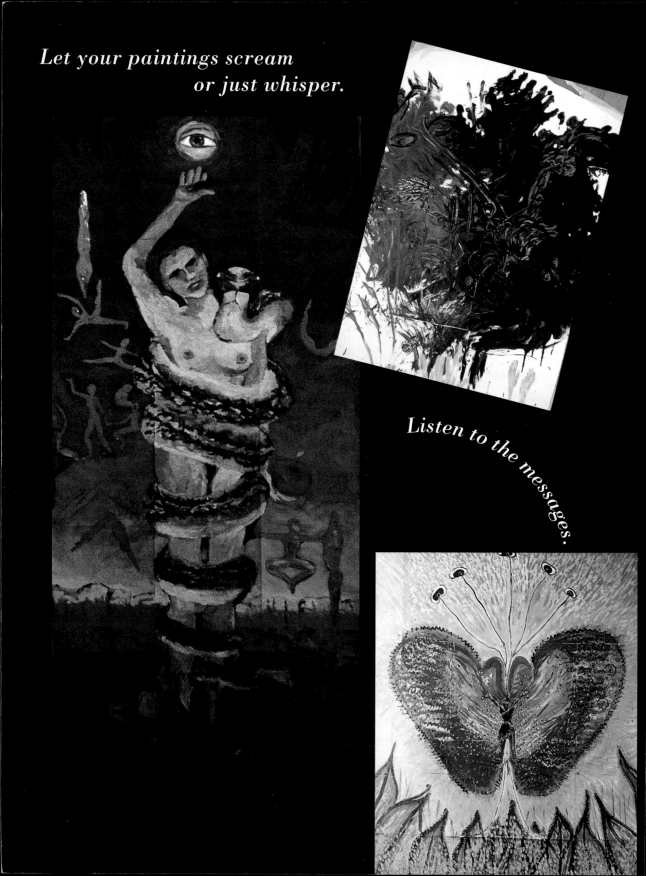

Let your paintings scream
or just whisper.

Listen to the messages.

and awed by people who do treat themselves to regular and frequent painting sessions. Have years slipped by as everything else took priority—cleaning under the refrigerator, arranging your photo album, matching all the socks in the drawer, straightening out the garage for the third time? Are you waiting to paint until you clear out that spare room or insulate the garage, perhaps as a painting studio for yourself? Forget all those mundane activities and procrastination tactics for now. Don't allow them to take precedence over fulfilling your deepest needs and desires.

My procrastination used to be so insidious that I'd schedule a Saturday morning painting session of a few hours, then arrange to meet a friend at five in the afternoon. I'd get involved in chores— telephoning, watering the plants, tidying the garage—until, suddenly, it was three o'clock! I'd finally get down to painting, but I'd be too rushed to get deeply involved.

Procrastination is often tied to an unconscious fear of jumping in and becoming so involved that painting takes over your life. My resistance is related, in part, to the fear that I'll become so consumed by the painting experience that I'll never want to return to "normal" life. I remember one instance when I was painting on papers attached to the wall of my bedroom, totally consumed with creating a circular rainbow that beamed through the bodies of a man and a woman seated tailor

fashion across from each other on the ground. The images and colors flowing from my brush thrilled me. "My God," I gasped to the friend who was painting with me, "this is better than sex!"

My "logical" self knows that painting is simply a continuation and enhancement of my so-called normal life. Among painting's gifts to life is the ecstasy of full immersion in our creativity and producing a painting we know, without doubt, is complete and whole. Painting from the source wraps you up and delivers you to wherever you need to be. And where most of us need to be is in a more empowered state of mind based on self-knowledge and self-acceptance. I know that plugging into the source, the God-given creative connection and expression that is my birthright, can never harm me. Yet, at times, I still find myself procrastinating, fiddling around with every conceivable household task, no matter how trivial, to avoid getting into my painting. Once I get going, I become lost, entranced in this process. Hours fly by, and I forget to eat because painting fills me more than ordinary food.

I tell my workshop painters that it's the mind that most often causes us to procrastinate. It fears that this absorbing, sensuous painting experience will render it obsolete. I have also learned that struggling to find the time to paint can also be tied to issues of self-worth. Do you deserve the free time required for this delightful experience? Do you deserve to paint images of your deepest, truest

self? Do you understand the true value of time? Yes, our time should be used wisely, but do you know the wisdom of giving yourself time to play freely and follow the wishes of your heart and soul?

Some of you may be aware of these issues and of the agendas that cause you to procrastinate; others of you are not. But each of you approaches the act of painting with very individual needs, issues, desires, and expectations. Some of you have never nurtured your creative inner child. Many of you will need to hush your perfectionistic inner critic so that you can play and experiment freely.

If you find yourself procrastinating, here are a couple of tips to get you going:

◆ Make a date to paint with at least one other "safe" person. You won't want to embarrass yourself or disappoint that person by breaking your date.

◆ Make sure that your painting setup is where you can see it, even if you don't touch it for weeks. This way, the setup is ready to use at a moment's notice, whenever inspiration strikes, and you won't be able to back out by telling yourself, "I couldn't get to my painting materials quickly enough." ◇

As you schedule your first painting session try to be aware of any little procrastination games you may be playing and enjoy a good laugh at yourself. Exercise self-compassion and have fun with it all. And here

is another of the many paradoxes you will discover in this process: The cure lies in the symptom. Only painting heals not being able to paint.

Scheduling Your Painting Sessions

The ideal amount of time to take for your first painting session is a weekend retreat. That's not possible for most of you, so take as much time as you can spare for that initial plunge. Then schedule your next source painting session as soon thereafter as possible, hopefully no more than a week later, so that you feel a sense of continuity. I have led many workshops in which each member worked on the same painting—most of which usually grew to at least double their original size—for three hours a week, seven weeks in a row. Most of the participants did not paint between sessions, yet the outcomes were powerful and, for many, life transforming.

Whatever time you take for that first session, whether it's an entire weekend, a few hours, or even a half hour, you'll discover that as you continue painting, your schedule will open up miraculously to accommodate more and more sessions.

Allowing Hand and Heart to Play

Some of you enjoy your body's sensations and all manner of sensuous pleasures, and, from time to time, you even like to float in

the mystery of the unknown. Others of you are less than comfortable with your body's natural physical functions, and you become impatient and/or anxious when confronted by the unknown or ambiguous. You may prefer feeling that you're in control and that you're "doing everything right." In fact, that describes most of us living in Western culture. We tend to be overly attached to results rather than enjoying processes, and to the material (possessions, surface beauty) rather than transient experience. Source painting counters that imbalance toward perfectionism and materialism. It gives you the confidence to trust and enjoy your body and its wisdom and to make room for surprises and the wonders of life.

While you are in this beginning painting phase, approaching your first breakthrough to the source, emphasize your "feminine" energy. This has nothing to do with gender and is what some call a "right brain" function. It simply means allowing yourself to be receptive rather than aggressive, spontaneous rather than following a strict plan, in touch with your body's sensations and intuitive rather than following the dictates of your mind, which is so emphasized in our Western education. Soon your valuable mind will be welcomed back as equally essential. Once you have fully tapped into the source, your masculine and feminine energy—that is, your "feeling" and "thinking" or left and right brain functions—will balance and work in unison. You will

experience what the poet William Blake called "the marriage of Heaven and Earth." In this mode, you will discover unmapped areas of your experience and explore the inner wellspring of creativity that expresses, as images in your painting, where you are in your life and where you want to be in the future.

How Much Time Does It Take to Get Connected?

Picking up your paintbrush is like turning on an ignition key and calling forth source energy so you become both transmitter and repository of the source. As you begin painting, your machinery may first need to clear away the rust of suppressed experiences and emotions that have settled on long-unused or never-used parts.

It can take several paintings before you finally break through to the source, because those first paintings often involve a letting go and clearing out of these suppressed experiences, character aspects, and emotions. Whenever these experiences and emotions present themselves to you through the colors and images in your painting, allow them to be there so they can be healed—that is, resolved and cleared away. Accept them as a condition of your painting process.

But you don't have to concern yourself with this. All you really have to do is turn on the creative source energy that already lives within

you and surrounds you; it's just waiting to be reconnected so that it can be used. If you don't believe me, rely on your "power of pretend." Pretend as you paint that you are perfectly designed for creative play and free expression and that eons of evolution and natural selection have brought you to this point in time and space where you will accelerate your personal growth and make a giant leap forward toward greater wholeness and joy.

Let's Paint!

Let's start with your sheet of paper. What size and position does your paper want to be? Sense the answer rather than making your decision on the basis of a plan. Does it want to be a long vertical? A wide horizontal? Does it want to be cut down to a twelve-inch square? Does your paper have to start out at four by six feet? Or is the present size just fine? If it or you need to change the size and shape of the paper, you don't have to know why, just do it. Either cut it to the size you want, or slowly, patiently, and carefully tape the necessary papers together. Remember, you cannot make a mistake. Anything you do from your heart and soul is an opportunity. Be open to the knowledge that your hand is guided by a force wiser than your mind. Be open to serendipity.

Now the right size sheet of white paper is before you. Remove the

tops of the paint containers so that you can pick up your brush, dip into color, and dance on paper. Allow your hand—not your mind—to reach for whichever size brush it wants and choose whichever color it desires, even if it's the last shade your mind would have picked. Now, allow your brush to move on the paper any way it wants. Doodle, let yourself go on automatic pilot. Send that mind on a much-needed vacation.

As you paint, keep in mind that you are not trying to paint a pretty picture or even a picture skilled enough to win the admiration of family and friends. This process is not about fulfilling an assignment, accomplishing a goal, or winding up with a finished product. In the early painting stages, I always tell my workshop participants, "Paint as if you will burn it." It is not about accomplishing a number of paintings. Your intention is simply to be in your body's experience of applying paint to paper and to stay with one painting, even if it transforms over and over again and/or grows larger and larger, until it is finally complete. Your gift from this completion is not a finished product but the relationship that develops between you and this painting that you stuck with through thick and thin, until it was truly whole and finished.

If it is at all possible, paint standing up. If you are comfortable in bare feet, kick off your shoes. Remember to keep breathing slowly, deeply, and rhythmically. Stamp your feet on the floor, feel the bottoms

of your feet planted on the floor. Relax your shoulders and abdomen. Do this periodically to keep grounded and in the painting flow.

You may have come to the blank sheet of paper with a haunting image from a dream, meditation, or reverie. This is also a good place to start. You could begin with a joyous or a traumatic remembrance, or even with what you remember of that blue daisy painting that your teacher ridiculed in third grade. Any idea or theme that calls to you is a good beginning. I caution you, though, that *begin* and *start* are key words in this process. This image or theme is only a point of entry. You must allow that image from your dream, meditation, or memory to evolve and change, perhaps into something that you don't initially recognize or even like. Surrender to wherever the images and colors take you.

Continue to heighten your awareness of the physical sensations of painting: the thrill of a first kiss in your belly when you plunge your brush into hot pink, sky blue, or glistening black and make your first wet, gooey, fluid strokes on the empty white paper. As the shiny, liquid colors flow onto the paper through your brush, feel the texture of the paper as the wet pigment slides over it. Let yourself become the delicious, slippery colors; be the shape, the line, the wash, the emerging image. Remember, you cannot make a mistake. You cannot do it wrong. And what we ordinarily call accidents are merely opportunities in the

Explore, Experiment, and Play

source process. Are you holding your breath? Let it out, and continue to breathe slowly and deeply. Let your breath keep you connected to your body and its feelings. Voice any expressive melody, song, sigh—any sound that keeps you connected to the physical experience of painting.

Allow your entire being to become absorbed and consumed by the sensuous liquid motion, by the rhythmic ebb and flow of colors and shapes, of images emerging and receding. Follow any path that attracts you; it doesn't matter which one. At this early stage in your painting journey, your intention is to paint yourself into a mild hypnotic trance, an altered state of consciousness similar to dreaming deeply or meditating. Within this realm of awareness, stay focused on your body's sensations, allowing pure, childlike, experimental play as you follow the movements and sensations of the wet colors, just as a meditator follows his mantra, the feelings in his body or the rhythms of his breath. Your mantras are "keep painting" and "trust the process." Use them to help you drop inhibitions and free your energy. If you feel yourself faltering and losing heart, remember that your body was perfectly designed to do this from birth and that it revels in free play and expression. All you need to do is move the brush mindlessly and get that mind accustomed to staying out of the way. Remember to keep yourself grounded in this body experience by breathing deeply into your belly, and releasing your breath slowly. Feel your feet planted firmly on the floor, and keep painting.

Are you generous with the paint, filling the palette, the brush, and paper with ample, juicy amounts? Or are you stingy? If you're stingy, are you also restrictive in your life, denying yourself and others the pleasures of living, as if there were only a finite amount, not enough to go around, *not enough for you?*

If you are obsessing over which color to choose and what to paint, do you habitually obsess about correct choices in your life? Your first major breakthrough might be realizing that any direction is perfect because you cannot make a mistake. All choices in this painting process lead to the source, to "other" logic. Do you see how painting in this way and the course of your life are so tightly joined that each reflects and impacts on the other?

Your first brushstroke initiates an ongoing dialogue between you and the painting like greeting a stranger with, "Hello, I am Aviva. Who are you?" Allow this exchange to unfold naturally and effortlessly: You and the painting are engaged in a developing relationship that alters with each brushstroke. You paint a line, a color and then view them, seeing that they have changed the painting, the direction of the dialogue. Now you respond to that change from your heart and gut, not from your intellect. Are you involved, absorbed? Or are you distracted? Are you allowing yourself to become involved, or are you "playing it cool," afraid of disappointment, rejection? Do you play it cool in your

life? Again, don't try to control the development and direction of your relationship with the painting. Allow it to go wherever it wants. Allow it to include any expectations, fantasies, hopes, disappointments, and fears, and any other aspects of yourself—those you recognize and those you don't. Just stay on your emotional and sensory edge so that you gain as much from this process as possible. Whenever you allow the relationship between you and your painting to build naturally and intensify, you stretch your capacity for intimacy and self-acceptance in all arenas of your life.

From Abstraction to Image: Painting It Out

Most of you will naturally progress from abstract to recognizable images if you stay with the painting long enough for those images to be ready to emerge and for your emotion to metamorphose into image and color. Bringing out those images gives the painting archetypal depth because you are accessing the internal landscape of your dream-maker, your deepest soul, the source language that all humans share. Don't be concerned if you cannot draw; draw from intuition, from the source. Trust the perfection of the stick figure. Let your inner four-year-old do the painting. Don't worry about right or wrong, and don't concern yourself with results. You're doing this for the pure sensation of it, for the crackle of unpredictability.

If your play forms begin to overlap and overlay each other, and the paint turns to thick mud, don't worry. *Be* that mud on your paper and see where that takes you. What could be hiding within all that mud? Is an image trying to emerge from the muddy chaos? As it shows itself to you, does it resonate and energize you, firing your core vibrancy? Pull out that image by allowing it to take further form. Paint the image out, details and all. If lines, shapes, and blobs of color begin to focus into a recognizable scene—an ocean, fields, mountains with eyes—does that scene want to stay? Does its foliage and wild life want to be unraveled and explicated? Allow these images and scenes to surface as they do in your dreams, no matter how outrageous, illogical, or bizarre. Then take up your smallest brush and paint in each and every detail. You cannot paint too many details. Remember to keep breathing, slowly and deeply. Let your shoulders drop. Shift your weight from one leg to the other, and keep painting.

Allow Your Painting to Grow

A wild, green hand is reaching into your painting from the lower left edge of the paper. A rushing river is cascading down from the top. Add sheets of paper so that you can explore these new lives entering the world of your painting. Or perhaps the painting is bursting at all seams, with images or abstract forms or lines pushing at its borders

and virtually spilling out over the edges. The painting needs to expand in all directions, so add those extra sheets of paper.

Once you and the painting are firmly established in your relationship and the images and theme are becoming clear, it's easy to know when the painting wants to grow. A tree has no room for its roots or branches, or a figure lacks feet or hands. You have to track a river or a road to its source, or a shape or line's energy is thrusting off the paper like a volcanic spray. An energetic image may be entering the painting from the edge of the paper. Perhaps your painting has become a face, the head of a person or creature, and you need to attach enough sheets to paint the entire body, every finger, toe, or claw, its tail, if it has one. You may need to add on sheets so you can explore the earth beneath your painting, because you sense something is buried there. You may need to move above, into the heavens. Or the angel you thought was in the center of the painting is really on the left side, with a mysterious egg now occupying the center, and you need more paper on the right for the half lion–half jester touching the egg.

Never add papers arbitrarily, only from the painting's pressing need. At first, it may be hard to recognize that need, but whenever you do recognize and fulfill it, the painting can move to an entirely new dimension. For example, you might be bored with that little tree or the face of the crowned woman you've painted. But when you add enough

98

paper to paint the tree's roots or the woman's entire body, what do the images become? Suddenly, you feel expansive and there's room for many exciting possibilities.

About one-quarter of the people with whom I paint feel the call to add paper in the first hour or two of painting, even while they're still exploring early, abstract, growing forms. Most continue to add paper throughout their process. Your body will tell you when to expand. Any desire at all to give your process room to grow should be honored. If those extra papers don't work, you can always cut the painting back.

Many paintings from the source naturally take on a circular theme. Either the painting's outline feels circular, or significant circular images find their way to the center. The circle is a powerful collective image; ancient yogis purposefully created round prayer paintings called mandalas. You may notice your own painting taking on a circular shape that needs more paper or, perhaps, trimming in order to be fully realized.

Whenever you add on papers, do it in a meticulous way, so the attachments are sturdy. This is analogous to building a firm foundation in your life and to obliterating your inner boundaries and providing the necessary grounding so that your true creative self can blossom and bloom. Those of you unaccustomed to fulfilling your inner creative needs may resist adding paper and/or add it in a careless manner. Do

you also resist the need for expansion in your life? Even if you feel lazy and resistant to expanding your painting, act as if you care, and add the extra sheets so that the final result looks like a smooth, continuous whole. Of course, you could have a specific purpose in making the attachments fragile and obvious, if that expresses a theme or issue that wants to be recognized and dealt with.

In general, though, approach these individual attachments as if they are part of your single, larger painting surface. Paint over the thin seams where the papers are attached; when one looks at the painting, it should appear integrated, with paint flowing freely over the whole surface.

Staying with Your Painting

Although most people resist recognizing that the painting needs to grow, others add paper arbitrarily, as an artificial way of switching to a new painting. Instead of continuing their painting onto the new sheets of paper, that is, allowing the same colors, lines, and forms to extend onto the added sheets, they use those extra sheets of paper as a sneaky way to start a new painting.

In these early stages, many of you will feel an overwhelming urge to abandon your painting and start a new one. Your mind whispers, "I like this, I want to save it." Or, "I don't like this, I want to start

over." Or, "This is okay, but I don't know what else to do." Or, most insidiously, "This feels complete, now I'm ready for a different emotion."

Ignore those whispers. Stay with the painting until you are completely in love with it, until you are overwhelmed by a deep sense of completion and surfeit. To put it another way, there are no bad paintings in painting from the source, only unfinished ones, paintings that have not been worked on long enough. Yes, there are exceptional instances when it may be appropriate to put aside an incomplete painting, and I will address this issue later. But for now, commit to staying with the painting long after you thought you could. Staying with the painting is probably the greatest challenge of this process, but it is key because it allows a critical mass of energy to build and carry you to the source.

As I've suggested, staying with the painting mirrors staying with human relationships or with projects that may have begun with high hopes and enthusiasm but, at times, have turned difficult and messy. Many of us have found it easier to abandon that person or project, rather than risk the pain of sticking through to resolution and completion. As you paint, imagine that your painting is a new lover or friend or even an aspect of yourself that feels strange and unknown. This can bring up fears, such as "My true unworthiness will be found

out" or "He/she will leave me." For those of you who feel a strong aversion to uncomfortable emotions, staying with the process will require dedication and courage. But you have everything to gain and nothing to lose. Follow your painting wherever it takes you—through boredom, humor, hurtful memories, hard work, moments of irritation, and flashes of unbridled joy—and you will receive an undepletable store of gifts. The essence of true art is transformation of the human condition, and that's exactly what you're after: to connect with the source and bring out your strengths and talents so you can enjoy a fuller, happier, more empowered life. Keep painting through what may sometimes appear to be false starts, detours, dead ends, accidents, frustrations, and struggles, and you'll get there.

Tricks to Keep You in Your Painting

If necessary, trick yourself into staying with that painting. Here are some tried and true tricks designed to keep you painting, even when you feel like giving up:

Trick 1. Paint faster and pretend you're going to burn the painting anyway. Perhaps you even will. I'm often told in my workshops that one of the most powerful pieces of advice I give to people who are stuck is to pick up the pace mindlessly. This shifts the energy, forces you out of your mind, and detaches you from the results. This trick is most

useful in the early stages of your painting journey, and after you've been away from the painting for some time and feel as if you no longer want to stay with it. Make a deal with yourself to paint quickly for ten minutes. By that time, you should have reengaged, perhaps even headed in an entirely different, more rewarding direction. If nothing happens after ten minutes of fast painting, switch your pace to idling. Just keep the brush moving, like a jogger running in place at a traffic light. Stay in the motion of image and color because that will take you to your initial breakthrough. Don't worry about losing images to which you've become attached. You can always paint around those that obviously represent an important aspect of yourself. And any lost images that want to be in your completed painting will find their way back in more powerful, evolved form.

Trick 2. Paint over something you've completed. But do not paint over an image that feels like a newborn part of you, one that bears a tale you need to hear.

Trick 3. Switch back and forth between the large brush and the tiny brush, so you alternate between minuscule details and massive, sweeping strokes.

Trick 4. Switch from your dominant to your nondominant hand. The nondominant hand has acquired fewer habits and defenses, so it is more connected to your spontaneous, unselfconscious inner child.

This helps you let go of mind chatter, and immerses you more deeply in the painting's life. It also counters any inhibitions and performance anxiety that may get in your way. By the time your nondominant hand has become proficient, those inhibitions should have disappeared. You can switch back and forth between hands as often as you like. Some people even prefer painting exclusively with their nondominant hand.

Trick 5. Switch between viewing your painting close up and from the furthest point in the room so you can better recognize any emerging images or themes that want to be brought out.

Trick 6. If you wear glasses, paint without them, and use your "inner" or "third" eye.

Trick 7. If you can't believe that the source is painting through you, pretend it is. Close your eyes and finger-paint. Make weird, wild sounds.

Trick 8. Tape yourself reading any parts of this chapter that you can play back and use for guidance while you are painting.

If any of these suggestions frighten, annoy, or otherwise disturb you, you probably need to try them.

...

Remember, it doesn't matter at this early stage *what* you paint, just the fact that you are painting, as if you were allowing a dream to unfold the way you watch a movie. The final frame of that dream will be your

multilayered, completed painting. It will contain the essence and radiate the energy of your entire painting experience, of all the previous frames in your movie. Each brushstroke and image of that painting, no matter how buried it may be under subsequent layers of paint, becomes an element of the painting's emotional and spiritual foundation.

Those of you who are trained in the arts may find that this emphasis on staying with the same painting goes against the grain of what you've been taught. You may be concerned about overworking the painting or worried that it will become too busy. "Less is more" is the dominant aesthetic memorized by art students the world over. But in painting from the source, more is more. Try to look at staying with the painting as an exercise, not as the way you will *always* paint. You will be surprised at how visually perfect your painting will be when you surrender to the source and stop trying. Staying with the painting may lead you to a truer style, your natural mode of expression. Even if you return to your previous ways after this experience, your artist's soul will be fully awake and your work will be deeper and more authentic.

Stay on Your Edge

One of the gifts of staying with the same painting as long as necessary to complete it is that it allows unresolved issues with yourself, with God, or with anyone or anything else to appear in your painting

and attract your attention. This is another reason why we resist this way of painting, at the same time we are so drawn to it. The images that emerge in your painting reflect the substance of your personal process; the emotions that flare up in response are your life spark. Staying with the same painting pushes you to your emotional and spiritual edge by bringing up such issues and dysfunctional belief systems as the need to maintain control, the need to be unique, discomfort with the unknown, fear of pleasure and/or ugliness, obsessive behaviors, and your ability to complete projects and/or forge and maintain intimate relationships. When these come up, they can initiate such feelings as anger, fear, or grief. Two common self-defeating core beliefs I've observed operating in myself and in my workshop painters are "the universe is basically hostile and unsupportive" and "I am unworthy and unlovable." Staying with the same painting will bring you into direct confrontation with those belief systems. The solution is to *pretend* as you paint that the universe is actually supporting you in this process and that you deserve support and love.

Painting in this way can even provoke physical symptoms—headaches, nausea, exhaustion, or bodily pains—for those who need to detox. If a bodily symptom, issue, or emotion wells up, welcome it as grist for your mill, wonderful raw material that you will transform through your painting into the gold of self-healing and replenishment.

Stay with any discomfort and paint it in exaggerated form. Call on your sense of humor. For example, if you like pretty, bright pastel colors and tidy images of flowers and hearts, and like being in control and neat, go ballistic. Staying on your edge may mean purposely painting the ugliest, messiest images and colors you've ever seen. If you register powerful bodily sensations, whether pleasant or unpleasant, such as an ache in your neck, a warm tingling in your groin, shaky knees, a wave of sadness, fear, contentment, or jubilation, ask yourself what that would look like in the painting. Exaggerate the sensation in your painting. What color, shape, or image does it take? What picture does it make? Paint on top of what is already there and consider making a larger space to display and contain these emotions by adding on more paper.

Maintain your intention to observe and stay open to whatever images and feelings come up and to keep yourself on the edge of that discomfort. If you feel out of control during this early, incubatory stage, you are precisely on course. Whenever you push against your limits, you inevitably feel uncertain, confused, and out of control. Remember, staying on your edge means walking that fine line between pressing what feels difficult and unnatural while also not foolishly abusing yourself by overdoing it. You must be the judge. Of course, just keep painting.

There Are No Shortcuts

Before you hit the mother lode of transformative issues that will lead you to your breakthrough painting, many veins of glittering fool's gold can lure you, usually in the form of aesthetically pleasing effects. If you have not painted for a long time or you're a first-timer, you won't want to part with these lovely beginnings. You want to save this painting and start again on a new paper. "I may never paint this again," you think. "I want to hold onto it. I don't want to ruin it." You may even feel you will become lost or somehow diminish in value without these attractive images. Release these images. If they belong in your painting, they will reappear, transformed and more potent. If you have to keep them, you can always photograph or copy any early images onto another paper. It's cheating, but only a little.

You may tell yourself, "I hate it and want to start again," because you do not recognize or value the images that are emerging from your heart. Or you don't understand or you fear what these images may be telling you about yourself.

All of these concerns relate to being overattached to results and to overidentifying the image on the paper with your self-image. As long as you give in to these concerns, you will never be truly free in your life; you will always be looking over your shoulder and worrying about loss.

108

Sarah's first source painting experience makes for a dramatic illustration of this point. A fastidious woman in her late thirties, Sarah had diverted her lifelong desire to paint into an interior design business. As she carefully painted delicate, watery flowers in the first hours of the workshop, she grew increasingly distressed. Sarah sensed that she was not as emotionally engaged as other workshop participants, whose paintings seemed more expressive. In the sharing session, Sarah confessed that she longed to express herself more powerfully, but she was fearful of painting something ugly or dark. Naturally, I suggested that she bury her anemic flowers under the ugliest, darkest painting she could make. Sarah dug in courageously, even using her bare hands to smear dark colors over her flowers and allowing spontaneous and primitive images to evolve as she emitted guttural, animal-like sounds. She also found herself addressing choice comments to her obsessively clean and overly restrictive mother.

As Sarah moved toward releasing her inner wild woman and assertive energy, her cheeks colored and her voice deepened and took on confidence. Gradually, her painting evolved into a lush garden—her *real* flowers—that seemed to have sprouted from the fertile ashes of the dark painting beneath. As she painted a tiny embryo in the pollen of a large golden-orange blossom, blood from a small cut on her finger dripped onto the painting. A wound that Sarah had "accidentally"

inflicted on her finger at lunch had reopened and bled onto the flower. Concerned, and at the same time recalling my suggestion that events we previously regarded as accidents or mistakes were really synchronous gifts and messages from the source, Sarah called me over. She wondered what, if anything, this could mean. I assured her that it was part of the process. We laughed about "opening old wounds" and putting "her life's blood" into the painting.

Unresolved issues inevitably find their way into these paintings, especially the early, cleansing ones. I took note of the embryo in Sarah's painting and asked if she had ever been pregnant. She told me that seven years earlier, she had undergone an abortion. Since then, she had felt ready for motherhood and had been trying for a year to become pregnant, without success. In fact, she was exhibiting all the symptoms of early menopause and was feeling sad and regretful about the abortion, although she had not expressed these feelings before.

Sarah was stunned that her unborn child had shown up in her painting, as she had no conscious intention to encounter it. But she recognized that the embryo image expressed an old wound that had reopened in order to allow her to complete her grieving. The embryo image also represented an unborn aspect of her own creative self that had come to the painting in order to reconnect. Sarah stayed with her painting, allowing the blossom's stem and roots to transform into

110

a graceful, dancing woman with the embryo in her heart. The onlooker need not know the story behind Sarah's painting to be touched by the love, devotion, and vivacity of its figures bedecked in jewel-like details. Three months after she completed her painting, an excited Sarah telephoned to give me the happy news that she was pregnant.

Unexpected images that come to paintings in order to bring a healing message can be viewed from another perspective. Painting from the source follows its own natural evolution, like sprouting acorns or newly conceived embryos, and as your painting evolves, so do you. Yes, your paintings do offer you clarifying images of yourself. But don't overidentify with any element you produce in the early stages, with what's either pretty or ugly. Don't let this evolving painting fix and define who you are. Like the process of human evolution, painting from the source holds no short cuts; it must be allowed to take form naturally, and it knows how to grow.

At this early stage, try to practice detachment, the cornerstone of all spiritual teachings. Stay with the painting and let go of your attachment to particularly attractive images, to making the painting look good. Release your fears that ugly images mean that you are ugly, through and through. Go through what *appears* to be pretty or ugly and you will discover the meaning of faith and realize that you are who you hoped you were all along.

As you paint, acknowledge that you are a true artist. An artist is not necessarily the one with special drawing skills, but the one willing to show up, brush in hand, at the blank sheet of paper—at the void that always precedes self-discovery. Doing this takes courage, passion, and commitment. Take pride and joy in your willingness to explore, perhaps to struggle, and to stay with it.

Outsmarting Your Mind

All the advice I've offered so far is designed to get you into the state of body consciousness necessary for your initial breakthrough to the source. As I mentioned earlier, the greatest obstacle to reaching that receptive state is your mind. It puts up a mighty struggle for supremacy and is rarely content to follow the body and hang out in the unknown. So here are some effective tips for outsmarting your mind:

◆The mind is often merciless, especially when it feels threatened by unemployment. It might tell you, "Don't you look foolish," "That's ugly, worthless, shameful, inept," or "What a waste of time; do something useful. When will you grow up?" Does that voice sound familiar, perhaps an echo of a parent or teacher? Recognize that it's not *your* voice. You were not born with this inner critic. So thank it for sharing, but tell it firmly that you don't need it right now. Each time it spouts another judgment as you're painting, visualize placing that inner

critic on a television screen and turn the on/off switch to off.

♦Is your mind-talk comparing you to someone who you think "paints better"? Again, thank your mind for sharing and tell it to take a break. Of course, it will keep coming back. If you get thirty seconds without those negative comparisons, you're doing well. Each time the mind pipes up, keep saying "thank you" and let it go. Eventually, it will take the hint.

♦Are you one of those people who needs to figure out what every image means? Do you keep interrupting your painting flow with intellectualized interpretations and analyses? Professional psychotherapists and art therapists are particularly prone to this one: "Oh, this must be about my traumatic early separation anxiety" or "This preponderance of black must mean that I'm depressed." Give it a rest. There's a time and place for everything, and the time for in-depth analysis is not while you're painting. If you notice your mind obsessing on interpretations and the need to understand intellectually, once again, tell it thanks but not now, please.

♦As you move in and out of your mind's booby traps while your brush is gliding over the paper, pretend you're four years old again. Pretend that you've never seen paint or brushes before. This can be very helpful. Ask yourself, "What is this stuff, what does it do?" For all you know, the paints are food you eat with the brushes.

You've never seen these liquid colors; you've never heard words like *masterpiece, talent, good* or *bad art*. This is a brand-new experience, and you're approaching it with a brand-new mind. You are seeing and feeling everything for the very first time with a child's delight, wonder, and enthusiasm. Dip your brush into color and become entranced by the simple magic of the wet brush leaving a colorful imprint on the paper. Place your face near the paper; paint with your entire body. Engage your entire being in exploring, experimenting, and responding. Return to that time before you learned to analyze, judge, and compare, when you were totally engrossed in the process and unattached to the finished product. If you can't recall such a time, start exploring without judgments today.

♦ You could pretend that you're the first man or woman to discover that a piece of wood darkened by the fire leaves a mark when rubbed on the cave wall. Or you're an extraterrestrial touching earth's paints for the first time. Or you're a shaman, a medicine man or woman who is performing a healing ritual that the source is channeling through you and onto the paper in order to heal or bring good fortune to you and your tribe.

♦ As you paint, pretend there is divinity and profundity in the simple act of showing up at the blank sheet of paper, ready and willing to paint. Pretend you are in a state of grace, open and vulnerable. You've

surrendered to an invisible hand that takes over as the painting paints itself . . . paints *you*. ◇

As you can see, the idea is to release all judgments, comparisons, and the need for intellectual understanding. At the same time, don't get so hung up on *not* making these judgments, comparisons, and analyses that you become too paralyzed to paint. I've seen that happen to a few "follow all instructions to the letter" types. You may want to write on a piece of paper: "Let go of judgments, comparisons, the need to understand, *and* of letting go perfectly." Post it where it can serve as a reminder as you paint.

Your Painting Intentions

Keep the following intentions in mind while you paint:

Intention 1. Allow your hand, intuition, and heart to choose the size of your paper and brush.

Intention 2. Allow your hand, intuition, and heart to choose colors and move your brush across the paper.

Intention 3. Remember at all times that you cannot "do it wrong." In painting from the source, there are no mistakes, no accidents.

Intention 4. Paint as if you will burn the painting when it's completed, not as if you will save it. Paint with your inner child's experimental, playful, curious mindset.

Intention 5. Keep painting on the same paper that you began with. This intention is the cornerstone of the source painting process.

Your painting can undergo extreme transformations, hold many layers of paint, fall apart and come together again in various ways, or it can grow with the addition of more sheets of paper. But your intention is always to stay with the same painting.

Intention 6. Whenever your painting needs to grow, sturdily secure additional sheets of paper to your original sheet.

Intention 7. If you are absolutely compelled to begin another painting on another sheet of paper, keep the first one hanging within view. Do not throw out anything.

Intention 8. Whenever you notice your mind chattering—making judgments and comparisons or analyzing and interpreting—just thank it for sharing and let those thoughts go.

Intention 9. Follow any emerging images that resonate within you and bring them out.

Intention 10. Allow those images, and the painting, to continue transforming, according to their needs.

Intention 11. Allow, follow, and express through your painting any bodily sensations and/or emotions that come up for you.

Intention 12. Commit to painting any uncomfortable, outrageous, or surprising images or colors that your painting and body suggest.

116

Intention 13. Notice what aspects of painting challenge you and bring you to your emotional edge. Stay on that edge. Staying on your emotional edge means expressing what you're feeling through the painting. Don't repress those feelings, and don't get stuck in them.

Intention 14. Paint as many details as you can. Your painting's true completion will be in those details.

Intention 15. Allow your painting to complete itself any way that it wants.

Intention 16. Enjoy.

. .

In the movie *Close Encounters of the Third Kind*, Richard Dreyfuss plays a sane, orderly architect, a loving husband and father who lives a conventional life in a "normal" American suburb. That is, until a spacecraft from another star system approaches touchdown on a mountaintop not far from his home. Suddenly, this "normal" husband and father begins behaving strangely. Although he's unaware of the impending touchdown, Dreyfuss's character finds himself obsessively drawing and sculpting images of the mountain where the spacecraft will land. He can not rest from passionately reproducing this scene, using any media at hand—his dinner napkin, the mashed potatoes, then clay and plants to re-create every minute detail of the mountain landing site. Finally, his bewildered, alienated family leaves him. Eventually, it

becomes clear that these alien visitors are calling him to join them on the mountain. Of course, he does, thereby fulfilling his extraordinary destiny.

Painting in this way will carry *you* off to a wonderful adventure, and although it will support your departure from people and situations that restrict your creative journey, it won't cause anyone to leave you. As you paint, close your eyes and know that you're engaged in a close encounter of the *source* kind.

DEEPENING YOUR EXPERIENCE

et's say
you've been painting for a while.

119

You know you could go deeper in your painting, explore further, but you sense that would take you into waters you're not sure you want to navigate. Besides, this painting is fine as it is. You've followed my suggestions and you didn't even expect to get this far. Or suppose your painting has captivated you, and some surprising and exciting images have already surfaced and seem to bear intriguing messages. Everything is moving along nicely, when suddenly, the wind leaves your sails, the sea becalms, and your connection to the painting disappears.

Painting from the source is often like that: periods of fertility that flow easily are suddenly interrupted by arid droughts. Sometimes you have trouble getting involved in the beginning stages; other times you're engaged and flowing nicely, when doubts, uncertainties, and resistances surface and stop you in your tracks. During those droughts you might be tempted to give up, instead of waiting patiently for that natural and soulful bonding to reestablish.

In these early paintings, you can be interrupted easily, at least for a little while, even by an image, line, or color that you find particularly stunning, because attractive images can provoke your attachment and fear of loss.

Don't be concerned. You haven't stopped; you've simply reached what we call an "incubation period," brought on by the natural wall of your resistance. Ironically, it's those incubation periods that will finally

allow you to reach true depth in your painting and experience the bliss of what I call your "quantum leap to completion," that is, the ultimate breakthrough that will reconnect you to your source.

Resistance and Incubation Periods

Bouts of resistance and incubation periods are opportunities for you to go beyond the painting as it is now—no matter how pleased you are with its prettiness or interest—to images of deep, soul-touching meaning and aliveness that will galvanize and delight you and work transformative magic in your life.

If you tend to be impatient in your life, allowing all the elements of your painting process to evolve naturally and organically to completion, this process will help you learn to tolerate ambiguity and waiting—a big lesson for most of us.

Barbara, an energetic yoga and macrobiotics teacher in her early sixties, came to a painting from the source workshop after being inspired by the spirit of freedom in the paintings of a friend who regularly painted from the source. Barbara arrived at the workshop eager to play with color and explore. Here is what happened next, told in her own words:

We are invited to select a brush and a color, and without forethought, begin painting. Just see what emerges. I go right for

bright magenta and a half-inch brush. I paint a curve, then another, a mirror image of the first. I add deep red curves to each side, then orange pops into my mind, followed by rose. I follow these impulses. Exhilarating! Suddenly, a vague uneasiness. Shouldn't this be something? A flower? A bird? How do I know if I'm trying to make something happen or letting something happen? I'm aware of my old habit of wanting to "do it right."

I hear Aviva say, "There will be a point when the paper tells you what it wants. Until then, just go on automatic pilot." I relax into inward listening, communing with my painting.

Aviva says, "If a figure seems to be forming, draw it. If you don't think you can, draw a stick figure." Thanks. I needed that permission.

My colors mix into a riot of heated vibrancy. I feel a calling for a delicate black line, then dots of brilliant blue-green. I think I want to put a woman's head under it—making a bird woman—but then it tells me it wants to be a butterfly.

From time to time, I stop to look around the room. I see beautiful shapes, glowing colors, chaotic lines, soft pastels, vibrating color combinations and black; recognizable shapes, circles, lines, shapeless blobs, movement, drama, lightness, struggle.

In some paintings, four sheets have become six sheets, then nine or even twelve. Every time I add paper, it's because the butterfly

needs to grow. It wants space, antennae, a tail. With each addition, I feel myself expand. I begin to recognize that this is liberating me from my lifelong tendency to self-limit, to hold myself to only one sheet of paper.

All around me, pastels are turning to mud. Shapes disintegrate. Then forms and images emerge out of chaos. I look at the other painters' faces marked with absorption, devotion, amusement, radiance, hesitation, irritation, withdrawal.

The next morning, Aviva says, "Just let it go wherever it wants to go. Your body knows how to do this. Allowing is an act of courage, of trust. It's the easiest thing in the world and the hardest."

My butterfly needs a center, a body. I paint a feminine silhouette like a figurine, legs together so that it looks like the center of a butterfly. I wind a spiraling garland of tiny white flowers and green leaves around her body. I shower a cascade of white petals and green leaves from her raised arms and hands. To my delight, the flowers and leaves become part of the design on the butterfly's wings. Stunning! New ideas come in rapid succession. Turquoise strokes, green circles with yellow centers.

After lunch, I go immediately to paint. My butterfly glows, vibrates, scintillates! I add mixtures of pink/orange, red/purple. I feel/sense/see my unexpressed passion, power, yearning, radiance, joy.

They exist in this dialogue between me and my butterfly.

Then I stand before my painting and the life seems to drain from it. Or from me. Maybe it needs green? Plants? I add three more sheets across the bottom and bring in leaves and flowers. The leaves and flowers feel fake. It all feels fake now! Aviva asks me what might be hiding in the grass. Perhaps an insect of some kind. A bug in my painting!

It takes me a while to recognize that my attachment to "loveliness" is boxing me in. Pretty forms without life. Or rather with only part of life's spectrum. Tentatively, I add a bug.

Mid-afternoon, the second day of painting . . . a time of resolutions and crises. A time of clearer definitions and articulations. A time of headaches, irritability, and heightened resistance.

"This is like the quest for the Holy Grail," Aviva tells us. "Don't give up. Your real quest is to stay with the painting, and yourself, until it, and your soul, connects with the source. You don't have to figure it out. Just experience and accept whatever happens in the painting. A place that feels uncomfortable may be your place of liberation, of richness and authenticity."

Sunday morning, the bug in my painting feels right. I try another. And another. Then lots of tiny flying mites. I'm tempted but afraid to add little animals to the grass. I don't feel I have the skills and I'm

124

afraid I'll mess it up, yet I know I have to do it. I want to do it.

"You'll learn the skill by going ahead and doing it," Aviva tells me. "That's all part of the process. If you sense something needs to be there, you will find a way to paint it in. The painting comes alive by giving loving attention to the details it requires."

I continue adding grubs and bugs and crawling and flying creatures. Quite a risk for me. And I love them. I know it is complete.

As I complete my painting, I see my journey from the initial passion and romance with my butterfly to the humble detailing of my grubs and bugs. I realize that my romantic intrigues were always separate and distinct from my day-to-day living. My butterfly expresses those romantic yearnings—beautiful, shimmering, and unreal in its separateness. The grubs and bugs are the necessary and grounding realities that give it life.

By allowing herself to stay with her painting long after her previous habits would have dictated, Barbara moved beyond her personal limits and into a new integration with her down-to-earth "grub and bug" self. This integration liberated a powerful wisdom appropriate to her mature stage of life and balanced the passionate young woman who lived in romantic fantasies that she had been with the wise sage she was becoming. The "earth creatures" gave Barbara'a pretty painting truth, life, and potency. Whenever you take creative risks like Barbara's,

you and your painting become more powerful and authentic.

Barbara's risk is one that virtually all of us have to take at some point or another. We have to let go of "doing it right" and then of the belief that "unlovely" elements, the bugs, will contaminate our painting—that is, contaminate ourselves. The first risk always paves the way for the next, and so on. Your periods of ambiguity and incubation gradually shorten and become more familiar and less uncomfortable with each subsequent painting.

Shamans in indigenous cultures make use of the same principle of healing that we follow in painting from the source: Whenever energy is suppressed in one area of our expression, it always expresses itself in an exaggerated, distorted, and self-defeating form in some other aspect of our life. Painting from the source is like receiving a "soul retrieval" from a shaman, like undergoing an exorcism and being healed. When you face the blank sheet of paper, brush in hand and ready to explore yourself through painting, your unconscious senses that at some point in this process, any unresolved issue, experience, or other aspect of yourself—virtually any unintegrated element your soul needs to resolve in order for you to evolve—will eventually surface and demand to be expressed in your painting. Once you paint images of a suppressed and unresolved issue or aspect of yourself, you will probably reexperience a degree of its emotional charge. *Capture it all* in color

and image. Bring it to your conscious awareness by letting it into your painting. This will take you a giant leap forward. You and your painting will move to a deeper level of engagement, that is, to an expanded consciousness that continually taps the source. And once you have painted that image, along with its unexpressed emotion, a new, transformational image will also demand to come out. So we paint in order to encounter, accept, and integrate these suppressed parts of ourselves, and we learn to appreciate them because they pave the way for transformational images that are even more genuine aspects of ourselves, the ones that will reconnect us to the source, our well of creative energy and wisdom. Don't be deceived into thinking that this is therapy and not art. It is both. Art is a healing for deeper art. This is true for us and all the painters who are known and admired for their originality and soul vision.

Once you've moved through your initial resistances, you will enjoy lengthier periods where colors, images, details, adjustments, and inspiration all flow, as if by magic. You're plugged in and the painting tells you everything it needs to express. Your inhibitions continue melting away, making room for that quantum leap to completion, that flash of illumination that will make all the difference in your life.

You reach a state of greater consciousness, where your innate sense of balance and composition takes over and expresses deep truths with

perfect economy. Sometimes, this perfect, unified flow doesn't happen until the last few moments of painting. But whenever it does happen, you feel the thrill of being more alive somehow. Even if you find yourself painting colors and images that would have repulsed you in a different context, their authenticity and vivacity will give you tremendous pleasure and satisfaction.

In other words, you kiss your inner frog in order to liberate your inner prince so the two of you can enjoy a happier, more emotionally free life. Painting from the source can be a way to say yes to life in all its rich and varied aspects.

It's not easy to kiss a frog, and whenever we encounter these froglike images of suppressed issues, conflicts, and unconscious beliefs, few of us are able to let loose with an exuberant, unqualified yes. Remember my initial reaction to others' paintings at my first painting workshop: "Oh no, I would never do that. That's going too far." You may be having fun when, all of a sudden, a rat, spider, roach, sexual genitals, vomit, feces, or any image you would normally reject automatically, appears in your painting. That image may even pop up "accidentally" among more acceptable abstract shapes. "There are some things that should not be painted," a painter acquaintance recently told me. I assume he meant some things are too demonic and awful to be represented. Of course, I don't agree. As I've already told

you, whatever elicits your strongest negative reaction is probably the element that most needs to reconnect with you and make friends.

So if you're saying, "I'll never paint this or that," don't be surprised if you paint that heretofore avoided subject in a *big* way. Forget the popular myth of the mad artist. Your painting may look crazy, but it will keep you more sane.

Nothing is too awful to paint. Remember your painting intentions? The *intention* of the painter makes the difference. These paintings may be powerful, but they can only accomplish good because they come through you in a state of authentic honesty and you accept them with an open heart. Whenever an issue surfaces in order to be painted and understood, maintain those intentions no matter what it looks like, and know that your painting is right.

Allow yourself to open up as much as you can. At the same time, keep in mind that it's perfectly natural for you to experience a degree of trepidation.

Resistance

Resistance results from a natural instinct to protect yourself from perceived danger. Your resistance can be provoked by the prospect of reopening the wounds of early pain experienced when you were too young and helpless to defend yourself. At the time the wound was

inflicted, you may have felt overwhelmed, without any means to cope. You can experience resistance over releasing habitual belief systems, behaviors, and ways of life that are well-worn routines but no longer serve you. Their familiarity gives you a false sense of security, and, despite the discomfort they continually cause you, you even resist giving up that familiar discomfort. In general, upsetting the status quo in any way can feel dangerous even if you fervently desire a new, more productive way of living. We also tend to resist the necessary transitional, or incubation, period between the casting off of the old and the arrival of the new. This period of waiting and emptiness often invokes our worst fantasies about the unknown.

Resistance can even be expressed as a physical symptom. A common one is fatigue, even exhaustion, despite last night's eight-hour sleep. Suddenly, you're famished, an hour after you ate a full meal. You quit smoking ten years ago, but now you want a cigarette. You could be nauseous or have a headache or aches in various parts of your body. You could have the full-blown symptoms of a cold or flu. As you obsess over whether or not to put a line here or there, you could break out in a cold sweat or in body hives. I've witnessed all of these symptoms, in myself and in others.

But most of the avoidance maneuvers provoked by resistance are mild, and often quite comical. In the middle of painting, you're seized

by need to phone your electrician, your thirty-year-old child, your spouse, or your mother. You're taken over by a sudden, overwhelming urge to clean under the refrigerator for the very first time. You can't stop fantasizing about meeting the love of your life someday, or about what you're going to do tonight. You could even find yourself in the throes of an anxiety attack and a compulsion to beat a hasty retreat from your painting space. You could succumb to an "accidental" injury or find yourself embroiled in an irrational argument. There are any number of amazingly ingenuous ways in which you can derail yourself from the process.

Cultural Resistance

On some level, resistance to painting in this liberated and unself-conscious way is inevitable, given our particular culture. This modern Western culture of ours tends to be uncomfortable with open displays of emotion—especially intense emotions such as anger, grief, and pain—even with expressions of tenderness and vulnerability. Our culture and its educational system instead value high productivity, achievement of goals, and easy disposability. Little worth is given to creative experience *for its own sake*. So, we have very few cultural role models that demonstrate the patience necessary to stay with a project and give attention to all the details needed to bring about true completion.

Our culture also avoids the natural body processes of birth, aging, and death. Even the color black and depression, both so filled with creative gifts, are seen as the enemy. On the other hand, indigenous cultures still possess trust in nature and are content with natural processes, like this way of painting, that unfold in their own time.

Natural, non–goal oriented painting activates your resistance related to these half-sensed social issues about open displays of emotion and allowing natural creative expression to evolve. You may feel self-conscious and self-indulgent about taking the time to enjoy the pleasures of an authentic creative experience. That is precisely why painting from the source is such a terrific opportunity to contact our fertile shadow side, vulnerability, authentic deep emotion, and true spiritual nature, and to heal from the estrangement so many Westerners suffer from. It is the same as in your dreams. The dark monster chasing you in your nightmares represents your most creative wild side. He has grown terrifying to wake you up to his need to be expressed. Paint him and love him as he is and the beast will transform into the beauty.

As I keep reminding you, at some point or another, your soul will bring to your painting, which represents your intimate relationships with yourself and others, any and every nuance of imbalance in your life, what- ever needs to be explored and adjusted. Only in this way can you realize the truth of your creative individuality and the meaning of your life.

132

Personal Resistance

Genuine creativity has always been healing, to the creator and to those who witness the completed creation. I am certain that the most admired painters throughout history experienced some degree of healing and personal transformation with each significant creative encounter. So, if you encounter any particularly tenacious issues and blocks while you are painting, they probably relate to your personal history. Painting through those blocks will lead to their resolution. On the other hand, until those personal issues and blocks that emerge as images in your painting are allowed to be expressed as fully as they need, they will keep surfacing in painting after painting, as well as in your life, and they will continue to impede your creative flow.

Again, view the personal issues, blocks, and any possible monsters that show up in your paintings as gifts, because they are nudging you toward your creative, and transformative, edge, where you can engage in the process and plug into your source. For some of you, this can happen in a single painting. For others, your breakthrough painting will happen as it did for me, after you have dealt with various issues over the course of several separate paintings.

After the reassurance of a series of birthing goddess paintings, hideous twisted and tortured creature painting was ready for me.

I will not nauseate you with the gory details, but to my surprise the next morning the painful arthritic symptoms that plagued me for years were gone for good. Physical symptoms, dreams, and paintings all come from the same soul source, which explains why if you do not inhibit your painting, you can heal your symptoms.

Let's examine some common personal issues that inhibit and block source painters.

Ridicule of Early Art

If your early artistic productions were ridiculed, chances are you stopped creating right there and then. You were having fun painting a blue daisy, when an adult interrupted you with, "Don't you know that daisies aren't blue?" Your creative spirit shut down, and you haven't picked up a paintbrush since. Now that you've started painting again, that old wound to your precious creative self has reopened. Trusting the source spirit once more entails a big risk. You have to confront the old fear that you can't do it right, that you may be defective, and perhaps go through a bit of anger at those who stifled your childhood freedom. Painting from the source heals this issue by helping you discover that *there is no right way.*

If your childhood creativity was squashed by such an incident, paint a childhood painting as you remember it. Paint it *your* way. If anger and sadness come up, paint them too. Be sure to paint

134

something the judges from your childhood would definitely disapprove of. And have fun doing it.

Overpraise of Early Art

If your early attempts at art were fussed over when you were just enjoying the freedom of play, you're not necessarily better off. With the weight of all that praise hanging in the balance, painting may have lost its fun and freedom, especially if you were a child who needed to please. (By the way, do you still need to please?) You had to produce works that adults approved of and liked. You may have searched for a formulaic painting style to ensure every one of your creations received the approval you craved. And woe to you if you won first prize in an art contest. For a child who lacks a healthy sense of self, first prize can be a kiss of death to his or her creativity. Painting becomes a task; the joy of the process is lost. It is no longer an activity you love but an act of compliance, a surrendering of your creative soul.

The situation is even stickier if a parent who denied his or her own creativity was living through yours. Children are sensitive to unexpressed emotions in others. So, if your parent was living through your art, you undoubtedly sensed his or her need on some level, and that burden of expectation would have become insupportable. You sensed your parent's ambivalence: wanting you to produce and make him or her proud, at the same time perhaps, envying your enjoyment,

creativity, and free expression. The act of painting became loaded and confusing. You sensed that you were showing up that parent, hurting him or her in some way, and/or incurring his or her anger and the threat of retaliation. This no-win double bind could have caused you to block your creativity. Children often bury their creative needs if they sense they might threaten a fragile family member. If you experienced this situation as a child, do you need to maintain that dysfunctional scenario either to keep protecting or blaming your parent and/or to avoid taking responsibility for your own growth and freedom?

Paint yourself all bound up, and then breaking free. Or paint yourself as the free spirit you once were as a child—or wish you once were—uninhibited by value judgments.

Only One Artist Per Family

Perhaps a parent or sibling was recognized in your family as "the artist." People sometimes talk in my workshops about a sister, brother, mother, or father who's "the artist in the family, not me." Some families perpetrate the belief that "there isn't room in this family for more than one." No room for more than one artist, beauty, outspoken person, successful person, or leader. Was there room for more than one "real artist" in your family? Even healthy competition is viewed as a threat in some families. If that was your situation, you may have felt like

136

a bad person for wanting to paint well, because painting was a dangerous act that could hurt someone you loved.

Try painting yourself being squashed . . . by anything. Then paint yourself painting alongside family members, with lots of room for each of you to express yourselves fully.

Physician, Heal Thyself

Psychotherapists, art therapists, and other practitioners of the helping professions confront a special challenge when they approach that blank sheet of paper. As I noted earlier, therapists can become blocked by their training to look for pathology, to interpret the hidden meanings of virtually everything around them, even in the midst of creating a painting. Therapists are also accustomed to and invested in being in control, in having professional composure and a clever, insightful mind. They often find it particularly hard to let go in order to experience their uncensored, vulnerable selves. Therapists often learned as children to take charge and help dysfunctional family members. In fact, they often did so brilliantly and effectively. As adults, they continue to be there for others, having chosen their profession from an unconscious need to help others as a way of avoiding examining their own pain and taking care of their own needs. If you are a therapist, you might find yourself standing before the blank sheet of paper with nothing to paint but long-neglected emotions and issues. You may even fear, as do many

therapists, that you are crazier than your clients. You protect yourself from your "madness" by denying yourself the freedom to just *be*.

The advice I give therapists who are having trouble letting go of their analytical mind and professional, in-charge personas, or to anyone who has read too many therapy books and/or is afraid of going mad, is to paint—you guessed it—a crazy painting. Paint the images and colors that would guarantee you speedy admission into the nearest psychiatric institution. Paint the diagnosis you most dread and have fun doing it. Lighten up. If you can't allow yourself to express your true feelings and be vulnerable and honestly revealing, how can you expect your clients to do it? Doctor, seize this wonderful opportunity to heal thyself.

Art Training

Unfortunately, today's art training is still modeled after the fifteenth-century European academies, which viewed the painter as a craftsperson and did not address sufficiently the need to connect spiritually and emotionally or the relationship between creating and personal growth. Within this type of training, little attention is paid to nurturance, stimulation, and protecting the artist's intuition, imagination, and soul.

As I've already suggested, if you've been trained formally, you might have to break habits and drop whatever mindsets and prejudices are blocking you. You may also have to heal from the trauma of

having your work critiqued. This particularly applies if training occurred before you connected firmly to the source as a child, before you were able to establish a healthy balance between humility and self-love. Of course, some art students have always been so grounded in their source connection that they are able to withstand their training and even use it to gain proficiency of expression. But if your training has blocked you, break all the rules. Paint whatever your most acclaimed, opinionated art professor would despise.

Art Snobbism

Art training can also lead to art snobbism. But the real cause of art snobbism is personal insecurity that creates the need to act superior. Those especially vulnerable to art snobbism include art critics, art historians, designers, decorators, and anyone else whose sense of worth and identity is invested in his or her artistic knowledge, sophistication, and good taste. Beauty is a necessity of life, but true beauty also includes comfort with the raw and ugly if that expression is authentic.

To liberate yourself from the affliction of art snobbism, paint the most unsophisticated, mundane, ugly, unprofessional painting you can imagine. Perhaps a child's stick figure? A happy face? Anything that could make you look foolish, inept, ignorant, and crude will suffice. Can you laugh at yourself? Can you be compassionate toward yourself?

Star Time

A variation on the theme of art snobbism and superiority is the need to be the center of attention, to be the extra-special star attraction for whom ordinary laws do not apply because, to put it succinctly, you are so dazzling. It's one thing to be outrageous as a result of your natural self-expression and quite another to be outrageous because you *require* extra attention in order to feel worthy or alive. This need often represents a misguided attempt to win the love you didn't receive as a child. Many people in the performing arts are reluctant to paint anything that will not guarantee them that big response from others. If that is your problem, remember that whenever you create, you are graced as a *vessel* for the source. But you are not the creator; *you* are not the source.

The Self-Esteem Seesaw

The delusion of grandeur and superiority, that only you are able to access profound, brilliant truths and beauty, often coexists with its extreme opposite, the fear that nothing inside you has value and/or that your inner self is a disgusting, childish, chaotic mess. The swing of the pendulum between these two extremes of self-regard is one with which I am quite familiar. It is related to what psychologists call narcissism, and it can be severely inhibiting.

Classically, a narcissist needs to believe that he or she is the very

160

best and remains insulated and anonymous in order to avoid exposure. Staying private and anonymous lets you nurse your fantasy and protect it from the awful possibility that you're really despicable, or, worse yet, merely average and just like a lot of other people after all. What if I proceed to paint and discover that I am not the greatest painter in the world after all? I'll have to give up this fantasy that sustains me and accept that I'm merely mediocre.

If this applies to you, painting "ordinary" will be a true gift of liberation. Paint the most mediocre painting you can. Paint something no one would give a second glance, something that is neither pretty nor ugly, neither safe nor shocking . . . just unnoticeable. This can be a real challenge, but it will prepare you for painting your authentic, noninvested self and for the realization that you are truly magnificent after all.

Decision Paralysis

Should you work small or big, use red or black? Are you fretting incessantly over the pros and cons of every painting alternative? Are you so paralyzed by doubts that you can barely get going? I have witnessed many people struggle with the simplest choices over the possible loss of one alternative, as well as over the possibility that the one they choose will be a horrible mistake. They want to stay safe. This dilemma is also an extreme example of being enslaved by your mind. Your fear of letting

go, of being out of control, is so great that your mind hangs on for dear life to whatever seems secure and familiar. But a large part of the joy in painting from the source is in making wild, intuitive leaps, in taking bold risks. It's only a painting after all, remember? You can always tear it up when you finish.

If obsessing over choices is your problem, making *any* decision without fretting and worrying will be your triumph.

What picture comes to mind to depict the agony of decision? Paint the mistake you fear; paint the paralysis. It may take the form of a simple image, such as you being crushed by a vise, or on a pinnacle with mad dogs nipping at your toes on one side and a roaring fire threatening to overtake you on the other. Or you can paint alternatives that represent choices of equal pleasure and freedom. Paint yourself in the fire or in the jaws of the dogs. Or caught between the pleasures. Or in knots, bound and gagged. Start with any depiction and see where it goes. Or you can try the generic standby: Place a large piece of paper on the floor, dip your hands and feet in the paints, close your eyes, and slosh around the paper on all fours, making appropriate accompanying sounds. If you can get yourself this far, you can make it the rest of the way.

The Need to Be Good

Sometimes suppressed issues cause us to compensate by acting overly sweet and placating, especially if those issues are associated with so-called negative emotions like rage and jealousy. A very sweet friend of mine was asked in a Jungian psychodrama workshop to symbolically decapitate Mother Teresa as a way to let go of her own overly angelic, martyr personality. She was shocked at the suggestion, but she overcame her resistance and complied. Amazingly, once she expressed her suppressed rage, the migraine headaches that had always plagued her disappeared and never returned. If you suspect that you're too sweet, paint the most fiendish, anti-angelic images you can imagine. Many workshop participants have told me that the suggestion that opened their outrageous side was "Paint what your mother would hate!" Have fun with it.

..

Take good care of yourself while you're painting. When you allow these hidden or suppressed issues, conflicts, and emotions to surface so you can accept and embrace them, you are in a vulnerable state. Give yourself lots of breaks, pleasant walks, nourishing food, pure water, and rest. Don't be surprised if you nap during the day or eat more than usual yet don't put on weight. You burn a lot of calories when you paint from the source—another bonus.

Be gentle with yourself. Your avoidance maneuvers were put in place for the purpose of protecting you. Be compassionate. Respect your resistance. Go slow, but stay on your edge and push gently—*don't shove*—against that resistance. Exercise discretion and respect. Just as we don't eat fruit when it is not yet ripe, there are times in your life when you are not ready to depict and work through certain issues, when it is not healthy for you to attempt to do so. Nothing I have suggested here has to be done *now*.

If you notice symptoms of your resistance, however fleeting, don't worry. Just maintain your sense of humor and follow any of the tips below that will help you recognize your resistance and maximize the opportunities to grow beyond it.

Tips for Breaking Resistance

Take a Break

Remember to pace yourself. Most of you will probably need encouragement to stick with the painting, but if you're overly conscientious, don't forget to take breaks. If you are putting in intense three-hour periods of painting, those times in-between when you're eating, sleeping, stretching, taking a hot shower or a long walk, can also be fruitful parts of your process. When you resume painting after a break, you are refreshed and see things with a new eye.

164

Painting Over

If your painting still has unpainted areas that want to stay white, *paint* those areas *your* white. If you know that the painting is incomplete, but you don't know what you want to change, paint a section over, using the same colors, shapes, or images. For example, if you've painted a field of grass, go over those blades of grass again, perhaps making them thicker, finer, or adjusting any other tiny details. Just let your brush idle; don't turn it off. Eventually, you will find a new and fruitful direction.

Paint the Details

Pick up your tiniest brush and paint in minuscule details, even if they are so small that you're the only one who can see them. This is a very powerful way to connect to your process, and a crucial aspect of your early paintings. At some point as you near completion, you will paint the fuzz on the peach, the pollen in the flower, the eyelash on the horse, the blood drop on the tooth. Even if your painting has no discernible images as yet, switch to tiny, methodical, detailed doodles. Embellish, decorate, cross-hatch, make tiny geometric shapes. "The devil is in the details," because creating these tiny markings will lead you to your most rewarding challenges. Actually, "*God* is in the details," because those details breathe greater life into your painting and you. Just as a single, minute detail in a work of literature can

open up an entire world to the reader's inner eye, the tiny details of a painting often inject the crucial element that grabs you, connects you to the painting, and takes you both to completion.

Those of you who may be uncomfortable with clarity and commitment, who may prefer sitting on a fence to taking a stand, may find that painting details moves you from lack of focus to your clarifying edge, that is, to realizing that discomfort fully and clearly. Getting to that edge and committing to staying there by painting it could well be *your* quantum leap, the one that resolves your inability to commit and adds an entirely new and gratifying dimension to your life.

Paint Big

If details are your forte, the style in which you feel most comfortable, paint with large, expansive movements on mural-size paper. You may discover that as your painting opens up, so does your life.

The Emergency Auxiliary Painting

I have suggested that occasionally, *very* occasionally, that first sheet of paper can be a warm-up. If you are absolutely convinced that you must go to a completely new sheet of paper, even start several paintings before you can become fully engaged, make sure that your first painting isn't revealing some aspect of yourself or experience that you buried because it was disturbing. If so, you may need to stop for a while in order to paint something lighter and reassuring. Auxiliary paintings

often include such images as an angel, a Yoda (the troll-like figure from *Star Wars*), a totem animal, or any reassuring color or figure that functions either as a spirit guide or provides humor and uplifts you.

If you go to an auxiliary painting, don't discard your incomplete first painting. At the very least, it could become a significant link to, or part of, another, larger painting. Even if you don't recognize it at the moment, everything you paint has meaning and a message. Those unfinished paintings will keep sending their images to your subsequent paintings. They came to you in the first place so you could complete them, and their motto is, "If not now, later."

Don't abandon your auxiliary painting either. Hang it in your view when it's finished, so it can provide you with protection and reassurance after you've delved back into your first painting to explore your discomfort. When you start a new painting on a separate paper, at first keep a space between the borders of your separate paintings until it becomes clear that the paintings are one—you will know when this happens.

Even if you think your first painting is complete, keep it hanging within your view while you paint the next. Keeping the first painting where you can see it leaves the door open for any unknown elements that want to make their appearance later. Sometimes an element enters the next painting that suddenly allows you to visualize the final,

inspired detail that was waiting to *really* complete that first painting.

If you have begun many paintings on many separate sheets of paper but haven't become engaged in any of them, limit yourself to six. Pick one painting to stay with or look at them all carefully to see if two or more paintings are actually parts of a larger single painting. Some people paint what they think are separate paintings that later reveal themselves to be pieces of a "painting puzzle" that, when put together, become a unified larger painting. Move your separate paintings around and line up their edges in various combinations, right-side up, upside down, sideways. If some edges fit, tape them together, hang them up, and resume painting with this new perspective. You will be amazed by how perfectly separate paintings can line up, with lines, colors, and shapes matching as perfectly as if you had painted them on one original sheet. Even if the connections are a little fuzzy, a little off, you can reinforce them with your paintbrush.

Remember, no matter how many paintings you begin or complete before your breakthrough, do not throw them away. Hang each one where you can see it, even if it only consists of a single line.

Words and Numbers

People who love and trust words and/or numbers often paint them spontaneously because they represent past moments of strong emotion or traumatic memories that have loosened and are surfacing in

their paintings in order to be healed. "No, yes, love, hate," various obscenities, and short poems often appear in paintings from the source because it's sometimes easier to write the word than to use images that graphically flesh out the emotion underlying the word. For some of you, painting the words that describe how you feel might be the giant step that gets you past your resistance and precipitates a breakthrough. In painting from the source, we play with images, but the lines and shapes of letters and numbers, and the colors we choose to paint them in, can metamorphose into images. Although the words are no longer discernible, they and the experiences and feelings they symbolize are still sewn into the painting's emotional and spiritual fabric.

While in the early, ambiguous struggles to connect with his painting, a writer named Paul was inspired to copy a poem he'd almost forgotten from a novel he'd abandoned twenty years earlier. Using several colors, he painted this poem on the paper, then hung the piece of paper on the wall next to his painting. It became a beacon and a catalyst that shook him up and activated his full engagement in painting for his truth. Since that workshop, Paul has been working on his abandoned novel with new fervor and commitment.

Repeating Motifs

If you find yourself compelled to paint nothing but large black circles or endless series of small red hearts, over and over, don't worry

and don't resist it. You're not crazy or ridiculous. Trust that something is in those circles or those hearts or whatever else you are painting. You may even find yourself repeating images and colors that disturb you. Remember, in painting from the source everything and anything are welcome. If you give in to your need without judgment or struggling to analyze it, you will reach resolution of whatever issues, emotions, or other self-aspects those images represent. They will either become part of your lifetime painting theme and you'll learn to love them, or they will evolve naturally into the next stage of your painting experience, which, of course, you will also love.

Search for Hidden Images

Scan for images that may be hiding in abstract shapes. Bring out any recognizable image and refine it. See what it wants and where that takes you. At this stage, when you are not quite invested in where the painting wants to go, it's often helpful to turn the painting upside down or sideways to open up new perspectives and reveal any latent images that want to metamorphose into their fully realized selves. They may even be calling out for more sheets of paper in order to be completely present for you.

Look for Pregnant Spaces

Sometimes you sense there's more to be painted, but you can't flush it out. Look for any spot that your eye keeps going to. It could be the

150

exposed throat or belly of a goddess figure or the empty river running through the center of your painting. Look for a space where you sense something is hidden that wants to emerge. There are always pregnant spots in paintings that are awaiting these smaller or connective images. Look for open, roundish shapes—seashells, foreheads, throats, chests, bellies, or genital areas of central figures. Or visually open areas such as skies, mountains, lakes, valleys, and open fields. Sometimes that smaller image—the tear in an eye, the embryo, the infant in a womblike shape, the heart in a chest—is not ready to be discovered and painted until the very last moment. Don't be afraid of making your painting too full, and don't hold back anything you see in your mind's eye. As I've already emphasized, the addition of that tiny flushed-out detail often shifts the painting, and you, into a completely different dimension that brings you to completion and plants the seed of your next painting.

Change Your Perspective

As you paint, periodically step away so you can view your painting from a distance and let it reveal new aspects of its energy. If you're painting while standing, as I've recommended, try painting for a while as you squat or sit cross-legged on the floor.

Express Yourself

Any expressive body activity such as deep breathing, foot stomping, and making sounds shifts your energy enough to jump-start or rev

up your painting process. Make any sounds or movements that express how you're feeling at that moment, or, better yet, how the painting would sound or move if it could. This can be very effective in getting you through incubation periods and back in your painting flow.

Paint Your Emotions

One of the most fruitful strategies is to paint images that express whatever emotions you are feeling at the moment, particularly if you have yet to plug in, even after trying all of the above suggestions. If that's the case, your emotions may include boredom, fatigue, frustration, hopelessness, or irritation, maybe even flat-out rage. All of these emotions and bodily sensations are grist for your mill. They are offering themselves to you to be expressed through the painting. What would the particular emotion you're feeling right at that moment look like on paper? Whatever it is, paint it in a big way. It could be a self-portrait of you next to whatever elicits your worst fear and disgust—snakes, bugs, dirt, germs, heights, tunnels, crowds, elevators, darkness, people copulating. Paint it, purposely and exaggeratedly. This is a guaranteed method to release creative energy that has been tied up in keeping you safe from your emotions and issues. Is your issue abandonment? Paint it. Are you obsessing about doing it—whatever it may be for you—wrong? Paint it. Let the worst, most extreme representations of your emotional issues emerge so that you are no longer controlled by fear of

152

them, so that you can finally break through the blocks they create and become fully engaged in your painting. Create metaphors: a lava-spewing volcano for anger, a shriveled blossom for fear. If fatigue is your avoidance maneuver, explore the leaden tiredness that has over-taken you. Does it feel slow, dark, heavy, drugged? Paint that. What do those sensations look like? What color is this inertia? What is its shape? Stay with the experience and don't analyze too much. Is your fatigue a drugged figure with a heavy, dark cloth over its head? Who is that figure? Are depression and emptiness part of the picture? Would a large paper painted entirely in solid black or a dead body express this feeling? From this death will come new life, so go straight into the heart of the experience, the full-blown sensation. Don't worry. This is an act of sanity.

When you summon up the courage to release the ugly, unmentionable, and detestable in your painting, you are open to the possibilities of change and transformation through that same painting. Images of shining creatures emerge from a layer of solid black paint; signs of life flash in a muddy pool. A crawling bug sprouts wings and becomes an angel. Just at the moment when your painting seems to be the most hopeless, annoying, unredeemable thing you've ever done, it is bringing you to a necessary and cathartic emotional release that will be a wonderful healing in your life.

Paint Your Pain

If you are experiencing physical symptoms, what do they look like in your painting? Paint that headache. Get into the pain, exaggerate it. What color is it? Red? Purple? What shape does it take? Is it shaped like your head? If it feels like a hammer pounding in your brain, who is holding the hammer? If it's a vise tightening around your skull, who is tightening it? Do your eyeballs feel like they're bulging out? Paint that. This may be your authentic beginning, the one that sends your painting off in a new, totally engaged direction. Remember, whatever form this symptom takes or whatever issue it is about, it's related to the block in your creative flow. You don't have to understand or analyze it. Just fearlessly paint any image that comes to you. Paint that headache (or stomachache, nausea, back pain, fatigue, or whatever physical symptom you may be feeling) so intensely, with such exaggeration, that anyone looking at your painting would know it was depicting a headache. Make sounds while you do this.

Follow the Painting's Needs, Not Your Plans

You may have had a plan for your painting and have been proceeding along nicely, when, all of a sudden, you hit a snag. Now, it seems that the painting wants to go in a direction of its own. Follow the painting, because the best and quickest way to the source is to let the painting lead you there. When you picked up that brush, you

committed to allowing the painting to show the way. You can be dragged along or you can go willingly. Your mind may struggle a bit, trying to hold on to its investments. Don't go with what your mind thinks. Go with what the painting tells you. How can you read your painting's wishes? Look at it and see what's actually happening.

Pam thought she wanted to paint an angel. She tried to paint that angel three times. Finally, she stopped struggling and accepted her growing realization that her angel looked more like a witch. Only then could she allow the witch to lead her in a rich and fruitful direction. Interestingly, after Pam accepted her witch, those angels finally made their appearance.

Mary, who was recovering from breast cancer, was painting an open, lovely hillside and fields in pastels and lemony colors. In the distance, below a light blue sky dotted with wispy clouds, shone the details of a charming hillside village. In the foreground, along the bottom edge of this graceful pastoral scene, rose a stone wall flanked by trellises laden with red roses. As she stepped back to take in what she had painted, Mary noticed that the rose-covered wall looked more like a wild, dark, cross-sectioned slice of a rich, subterranean world. Knowing that there are no mistakes, no accidents in painting from the source, Mary took this cue from her painting rather than trying to think of what she should do next. She proceeded "mindlessly" to dip into

blacks, deep reds, and rich browns and painted out all those mysteries buried in the earth—shells, fragments of roses, worms, and other remnants of surface life. The painting became much more intriguing, magical, and empowering than the pretty picture she had originally planned.

Free-Associate

If you want to go deeper and bring out more engaging imagery, look for an empty space that draws your eye. Look at that river flowing through a jungle scene or the road that cuts through a forest or the large tree in the right corner of your landscape, and say the first twenty things that come out—fast, in a rush and without thinking, without concern over whether or not they make sense: boat, fish, snake, person swimming, bubbles, stars, alligators, lily pads, blood, basket with a baby, serpent, woman's body, woman's body giving birth to a serpent—whatever comes. As you reel off those twenty things, notice if one or two resonate and stir you. Don't worry if they're illogical, paint them. You might not have to list twenty before you hit the right one, or you may have to list over forty.

Dialogue with Your Painting

Another fruitful technique for breaking through to the depths and discovering what additional details your painting wants is to actually dialogue with the painting and/or an image within it. Ask what it

156

wants, then take on the role of that image and let it speak. What it says may surprise you: "I'm hungry. I want fruit in my bowels. Give me grapes. Give me champagne." A fish may tell you it wants silver scales. If you dialogue with characters in your painting who represent people close to you—parents, spouses, children, or siblings—the conversation can be both auspicious and healing. The same holds true for archetypal aspects of yourself that appear unexpectedly. Even if you don't think you need help with your painting's completion, dialogue with all its entities, including plants and animals, rivers and rocks. Ask what they may need and what they have come to tell you.

Dialogue with Your Devils

Dialoguing is particularly helpful if an image in your painting perplexes or disturbs you. Remember that it represents a part of you, so ask it to tell you its story. Then listen with a compassionate heart. The "devil" will probably tell you that your neglect made it appear as it does, but only for the sole purpose of getting your attention and waking you up! Accept and negotiate with it, and that image will transform into a devoted ally whose energy will release and power your creativity. Simply allowing any of the surprise aspects of your self in the form of images is liberating.

Skill and Authenticity

You may be thinking, "If I were skilled enough in drawing and controlling paint, I could make my paintings look exactly as I want them." Admittedly, training and skill provide surface dazzle, accomplishment, and appeal. But dazzle can distract you from genuine connection with the source, from going as deep as you can to experience your authenticity. Experienced painters sometimes require more time than novices to get to the source because they have a lot to unlearn in order to allow themselves the same "accidents" and "slips of the hand" that are so essential to this process. Surface technique without soul is like wax fruit: It may look better than the real thing, but it lacks juice and life and never undergoes natural, organic transformation.

The best way to learn to draw is simply by doing it. Through hours of moving the brush, playing with paint, layering images, following the dictates of your imagination, and what may seem like countless false starts, you will naturally gain competence and skill. Whatever you learn in this way endures longer and is absorbed more deeply because it was gained from your soul's need. If an image arises from your soul, your hand usually finds the right way to express it. If it should happen that your mind does not yet know how to draw the black horse that must stand on your hilltop or the dancer's fingers that must assume a

particular gesture, take a moment to look at pictures of horses or to make the hand gesture yourself. Copy what you see into your painting. Study whatever you need, from life or a picture, and then reproduce it. It may not be a photographically accurate image, but it will have the soul or essence that you and other observers will recognize. As you acknowledge your growing mastery and skill, you will gain the confidence to attempt more complex techniques and images, such as perspective and the faces and bodies of humans and animals. This takes some time, but you will soon discover that just as you realize you need to paint something, you somehow find the assistance and skill to paint it.

Allow Dream World Logic

Just as I urge you to go with what the painting wants, even if it's the opposite of what you *thought* you wanted, be open to the creations of your poetic, metaphorical mind, to dream world logic. Allow the illogical, take that artistic license you've heard about. In dream analysis, we say that a symbol never represents one thing *or* the other. It presents one thing *and* the other. The same is true for painting. You step away from the mountain range you painted and, suddenly, it assumes the shape of a reclining woman. It doesn't have to be the mountain range *or* the woman. Allow it to be a mountain range with the shape of a reclining woman or a reclining woman who looks like a

mountain range. If the underwater scene you thought you were painting looks like the sky, go with an underwater sky. If a parrot looks like an old man, go for that old parrot-man. It does not have to make sense for it to be art or meaningful. We have cameras to capture the logic of linear, one-dimensional "real" life. Like our dreams, art stretches us and makes us this *and* that—more than we ever imagined we could be.

Paint a door in the tree trunk, a face in the moon with fanciful creatures dancing in its glow, a hole in the ground filled with sky, an eye on a nose, a face in a flower, a three-headed creature. Paint X-ray versions of people and creatures that reveal not organs, but fish swimming in bellies or flowers breathing like lungs beneath ribs. These imaginative and dynamic juxtapositions are created by a collaboration between the painting and your receptive imagination. You can make anything happen in your painting: people can walk on ceilings or snakes may grow out of a head. You can be as outrageous as you wish, painting your wildest fantasies and your strangest perspectives. If you feel embarrassed, that's okay too. You're not crazy; you're an artist. And whatever makes its way up from your artist's psyche and enters your painting, don't forget those minute details: each feather of the horse's wing or the tiny crescent moon and stars in the goblet of violet-blue grape juice.

Postpone Immediate Gratification

If you experience an urge for any activity or substance, be it a particular food, pain pills, sweets, alcohol, drugs, caffeine, a shopping spree, sex, house cleaning, working, exercising, watching television, a temper tantrum—and that's just a small sampler of the various means by which we anesthetize ourselves and avoid dealing with our issues— your resistance response is at work. You know your favorite means of resistance best. My suggestion, in case you haven't already guessed, is to postpone that gratification. If your urge doesn't involve an addiction, that is, if it's not a genuine chemical dependence, work through the urge by painting whatever feelings come up. They are the same feelings that you habitually sedate and suppress with the addictive substance or behavior. If you are addicted chemically, delay gratification long enough for the urge to serve as material for your painting.

What feelings come up? Paint them. Paint the yearning too, and paint what the imagined gratification would look like. In other words, hold off smoking that cigarette a few moments longer and paint the desire and pain of not having it. *Then*, you can smoke that cigarette.

Your goal, for the purpose of your painting, is not to cure yourself of chemical dependency, though that may happen as you express and release the underlying reasons for your dependency—the issues and feelings that your addiction masks.

Bring Back that Mind

Because of the overemphasis on the power of the mind as opposed to the wisdom of the body in Western education, I've emphasized painting in your nonanalytical, feminine mode in the early process; that is staying receptive and intuitive and allowing your feelings and body to express itself without the need to understand or analyze what is happening. This leads you to the natural balance of feeling and thinking necessary for your breakthrough and true completion. The mind is as essential as the body in this process.

Many people at my workshops worry that if they act upon an idea—even a spontaneous one—they have stepped out of the process. The opposite is true. Ideas can and do surface from intuitive play. If you recognize an emerging theme, know that you are being called to expand and embellish it. The mind is an integral player as you choose the right colors, rearrange or paint over images, add detail, and explore the deeper levels of your creation. When you are plugged into the source, the intuitive body and knowledgeable mind dance in harmony, supporting and playing off each other.

Remember, as you paint, that the symptoms of resistance are not an enemy or oppressor to be vanquished with a pill. They are grist for your mill, opportunities to delve deeper into your transformative

process. Invite them to express themselves further through the painting, and thank them for giving you rich material to work with and transform into greater self-realization and health. Guess what? After you finish painting your pain, anger, fatigue, or indecisiveness, you probably will discover that it's gone.

Quick Fixes

The following are quick fixes to unblock yourself for painting. These fixes are jumping-off points that work no matter what has provoked your resistance. See where they take you.

◆ If you feel stuck, paint yourself stuck in the birth canal. Maybe you were. Paint any birth trauma or in utero trauma you may, or may not, have experienced. All preverbal trauma (even those from past lives) inhibit creativity.

◆ If your internal judgmental, authoritarian voice rings too loudly as you paint, paint images of that critic silenced or eradicated and/or paint whatever he or she would hate the most. Get sadistic.

◆ If your critic is cynical and overly logical, paint everything that nonbeliever hates: a gooey, sentimentalized angel with rainbows, hearts, flowers—the works. Paint that critic in all his or her cynical, domineering glory. Then dialogue with your critic and see where that takes the two of you.

◆ Are you overly serious? Paint something silly and ridiculous.

◆ If you fear making a mess, make one. Paint feces and vomit. Have fun.

◆ If you feel bound and victimized, never free to be your own true self, or if you feel martyred, paint yourself bound or nailed to a cross. See where that takes you.

◆ If you have a health problem, it will probably find its way into your painting, even if that wasn't your plan. So go ahead and paint your entire body as it is; depict the condition inside your body with X-ray vision or in any way that it wants to appear. Ask that health condition what it wants and listen to the answer. Then allow it to evolve and transform as it chooses. And don't forget those details. ◇

If a part of you doesn't want to grow, heal, forgive, let go, reconnect with the source, or be happy, that's okay. At least you're being honest. Paint your spite, resignation, stubbornness, or revenge. Paint your rebellious, recalcitrant inner child. That kid needs your love too. If you need extra support and guidance with issues that arise from the painting process, please see the appendix: Therapeutic Help. These referrals are in alignment with the Painting from the Source process.

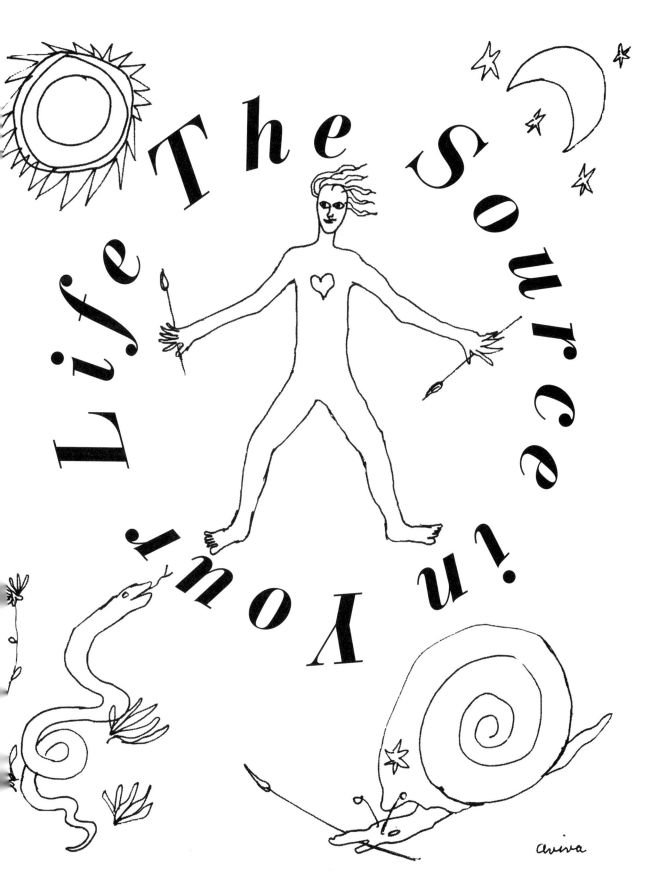

Completing Your Painting

y now, you and your painting have probably traveled a good distance together.

You may have emerged from confusion and ambiguity, and the painting's final form, images, story, and message are now apparent. Under ordinary circumstances, you would say it's complete. In fact, you may have thought that you were finished more than once. You've already exceeded your "usual limits," but as you know, there's nothing "usual" about painting from the source. The ultimate reason why I paint in this way is that it allows me to push my limits and explore newly discovered parts of myself that create wonderful transformations in my life.

Within the extraordinary experience of source painting, you can undergo a series of such breakthroughs and illuminations, plus a culminating quantum leap breakthrough that sometimes occurs in the last moments, when you are painting the final elaborative details. In other words, at precisely the moment when most painters are satisfied with their results, I suggest that you go even further to flush out deeper and previously unimagined final gifts that will transform your solid, substantial painting into a work of soul-magic beauty.

What I am describing is similar to what happens in nature when a period of growth reaches critical mass and makes a transformative quantum leap, such as caterpillar into butterfly or dough into bread. In the painting process, painting energy builds up exponentially. There can be many quantum leaps during the process, but often the most

168

powerful coincides with completion. Trust that you will *know* when it happens.

Barbara reached her quantum leap breakthrough after she allowed an "ugly" grub to appear in her painting. For Sarah, it was acceptance of the embryo in her painting. If you are sexually inhibited, your quantum leap could be in daring to paint nude people. Another could come after you've summoned up the courage to paint their genitals. You could think you were finished, but your final quantum leap could be painting the sperm and ova inside their bodies, or painting two naked people making love.

So what does it mean for a source painting to be complete? What does it take? How do you arrive at that place where your painting is truly finished and takes on its own life?

Knowing when your painting is complete can be a major issue. It can even come up within the first five minutes of painting. As I stated earlier, if you have any doubts, your painting is not complete. You will know the painting is complete by your overwhelming sense of satiation, vibrancy, and love for what you've created, and by a dawning awareness of what your next painting must embody. But that is only part of the answer.

Completion means the painting moves beyond a combination of colored pigments on paper to become an emotionally and spiritually

vibrant entity, a living record of your experience. Much art *approaches* this point of aliveness. Source painting goes *beyond* that point to realize art's deepest alchemical potential. The painting becomes a work of power and beauty, much more than the sum of its parts, because it has drawn from and touched the source, that is, your soul. As the facilitator of this creative magic, you, the painter, are transformed by the creation that you channeled. And those who view the painting and "hear" its story are also enlivened and moved. This level of completion requires vision, commitment, faith, and patience. The payoff from this level of completion is a new, broader comprehension of life and a more fulfilling way of being.

You must be willing to wait and search for that final missing detail, no matter how tiny it is, no matter how long it takes you. That doesn't mean you have to push and struggle. You simply do your part. Show up, do what you can, and allow the universe to take care of the rest. Like a fisherman, release your line into the water and wait.

Have faith that you will find the final, necessary brushstroke, image, or tiny addition that will transform your painting into an object of awe, and that if and when you are ready to show it, your painting will also speak to others. Your question should not be "Is there a final piece to be found? Does it exist?" The final detail is always there. Your real question is, "Am I willing to stay with the quest however long it

takes for that final detail to appear?" For some of you, an unequivocal yes answer will be a breakthrough in your process, a leap forward toward satisfying your soul's deepest desire for you to become the person you were meant to be.

Completion comes after you've experienced a painting breakthrough—a shift that occurs within the painting and within you—a jolt of illumination some people call the "aha," combined with a delicious flood of ecstasy. But that happens only after you've stayed on your particular edge of discomfort and with your painting's ambiguity long enough for a critical mass of energy to build and carry you through to this ultimate quantum leap breakthrough.

If you keep painting from the source, you will experience a series of major breakthroughs. Some of these may be about developing the patience, commitment, and confidence to search and wait as long as it takes for the final details of your painting to manifest and give your painting, and your self, new authenticity and soul. In fact, your first quantum leap breakthrough could be about finding the willingness to paint in the unknown, to rest with chaos and the ambiguity of many possibilities, and to face the fear that you may never connect. For some of you, portraying this fear in your painting could be a quantum leap breakthrough. Your next one might be the appearance of some long-forgotten or buried issue that you thought was dead but is

actually faithful, smart, loyal, unforgetting, and instinctual. It knows you need its resolution and it comes to your painting to help you heal. A breakthrough may involve your acknowledgment and depiction of any issue, addiction, trauma, or other suppressed aspect of your self or your history.

Arm yourself with faith and inspiration, and use any of the following tips to help you push past any remaining resistance and access the magic of completion:

Tips for Completion

◆ Add any obviously essential details such as fingers, toes, roots, tails, or a final sheet of paper.

◆ Add any element you held back from, whatever you may have thought about painting but didn't dare.

◆ As you scan the painting, ask yourself, "If I were to do one more thing, what might it be?"

◆ See if anything is hiding in the painting's center or in a circular shape or near any of the body's chakra centers: the top of the head, the middle of the forehead, the throat, the heart area, anywhere in the belly, or genital area.

◆ If both you and the painting want it, consciously alter an image and/or its focus.

192

◆ Smooth out, clean up, touch up, give a final edit, biding your time and staying engaged while waiting for that final flash of inspiration to strike.

◆ Use any previous suggestions for breaking blocks, such as naming twenty things quickly or asking the painting what it wants.

◆ Ask a major figure in the painting what it wants. Then speak for it. I suggest that you not dilute the process by recording the dialogue in your journal. If you feel compelled to write it, speak it aloud as well. I have witnessed astounding reusults from this query, such as when one painter asked a hideous beast in her painting what he wanted. His reply to her surprise was that he wanted a king's crown and scepter and a red heart painted in his chest. The painter wept as she obeyed.

◆ Be open to the possibility that the painting's final detail could come from a medium other than paint, such as body fluids, hair, ashes, or anything from nature.

◆ The final touch could be a signature of some kind, a mark or symbol that carries meaning for you, such as the sun or moon, a beetle, a bolt of lightning, a Greek, Hebrew, or Sanskrit letter, an Oriental figure, or any exotic image that calls to you. Don't be afraid to be corny.

◆ While doing any of the above, change your position in relation to your painting. Move closer to it, or farther away, and take in the entire painting. Surveying the complete scene elucidates connections and associations.

◆ Talk to or bring in a painting buddy or trusted friend. Describe or show that friend the spot you're wondering about. See if he or she gets an intuitive illuminating hit. Always keep in mind your safety guidelines.

◆ Live with your painting. If you get a sense of the next painting, begin it. This may lead you back to your first painting and that final satisfying detail.

◆ As the final details come to you, even if you think you understand their meaning, be open for their ever-deeper levels of significance, even the possibility that you may never comprehend them fully.

◆ If all else fails, there may be a need for radical change, complete redefinition, a shift in perspective, and smashing the old in order to release the new. You could turn the paper upside down and finish the painting that way. You could tear up the paper and glue it back together in a new arrangement. Being real sometimes means being outrageous and subversive in the finest sense of those words. ◇

If you want to recover what your soul desires, you must be willing to destroy whatever you've painted and refuse to make it easy or convenient for yourself, because you know there are no shortcuts. This willingness to let go and wait for what comes next is what takes you to completion and rebirth, where you naturally shed beliefs and behaviors that no longer serve you.

194

Betty, an attractive art teacher on the threshold of her fiftieth birthday, came to a recent painting from the source workshop retreat. She expressed an ambivalence about aging that is common among many women in our culture. On one hand, she was drawn to the pervasive youth and beauty mystique that denies aging, that dyes gray hair and surgically removes telltale wrinkles and droops. On the other hand, she was attracted to the opposite, to embracing her maturity. She was even torn between having the gala birthday bash her husband wanted to throw for her and creating an intimate rite of passage with women and a few close men friends. Betty didn't fully realize it, but she had come to the workshop to paint this struggle and, hopefully, resolve it.

At first, Betty relied on her high skill level. She painted exciting swirls of colors in which a shapely female silhouette tossed about. In the first group sharing, Betty voiced her discomfort and sense of chaos, both within herself and in her painting. We all agreed that since the chaos made her uncomfortable, she should stay on her edge and intensify the chaos. More figures swirled in the painting. She painted a black border that crept inward to form a circle. Within the circle, a large, shapely naked woman and other pretty colored figures tumbled and danced in every possible position. But even with the black border and her attempt to heighten the chaos, Betty's painting remained attractive and eye-catching.

She was having difficulty staying in the uncertainty of chaos and maintaining a lack of resolution, that is, in hanging out in the unknown until a genuine, spontaneous painting impulse overtook her. "I can't explain it," she said irritably. "Somehow I'm still selling out." Anyone in the room would have bought this pretty painting, but Betty knew what she had to do. After a day and a half of struggle, she dipped her brush in black paint, and, to the accompaniment of her tears and a chorus of astounded gasps from the group, covered the entire painting.

Bright, even more vibrant colors reappeared over the black. A shaman's head gradually emerged, and Betty painted it out, revealing a wild, aboriginal face whose open mouth was framed by the open palms of its hands. Details found their places—spirals on the hands, an elaborately decorated necklace, hair, and a throat. But the open mouth remained empty, a big pregnant circle . . . waiting. Betty knew something significant wanted to be there, but she patiently painted details elsewhere, until the painting told her what to do. She was becoming wise.

Through covering her beautiful, much admired painting with black—in effect, symbolically embracing the "death" of her youthful beauty—Betty became more open and vulnerable. This quantum leap breakthrough brought her closer to her true destiny of mature wise woman. She allowed part of her former, superficially pretty appearance

to die and embraced with bittersweetness the inevitability of her aging—her "sageing," as it were—thereby coming to terms with her own mortality as well. "I want wrinkles to be beautiful," she cried out, as she symbolically released her former ideal, the unmarked beauty of youth, and freed herself to understand beauty in a more complex and profound way. She did this by patiently and confidently staying with the tension of the unknown, in her case, with the yawning emptiness of the wide-open mouth.

Suddenly, in the final fifteen minutes of the retreat, a gaggle of white, dancing skeletons began tumbling through the African shaman's dark throat and out the great cavity of its mouth. The skeletons looked as if they had been waiting inside millions of years for the chance to come out and play. With their addition, Betty's already striking totem painting grew even more astounding. The plump, many-colored, dancing cherub-women buried in the layer below the black paint had reappeared, transmuted into these skeletons that were dancing out the shaman's mouth. That floating, swirling, "pretty" painting Betty began with had transformed into a riveting, grounded, committed vision. And the same was now true of Betty.

Like all quantum leap breakthroughs, Betty's came in the form of an unexpected surprise that happens only after you have lost yourself in a living relationship with the painting, where you follow it, every

step of the way. Betty arrived at a point of perfect resolution that carried both the certainty that nothing was left to paint and a strong sense of how she would begin the next one. It would begin with the full figure belonging to the head of the genderless shaman.

When you paint in this unconscious yet committed way, each hour of painting becomes exponentially more powerful than the one before. You enter a state in which you feel that your hand is guided. At times, your painting seems to be a chaotic mess of complete discord, even up to the final minutes. Then, suddenly, in those final moments, the energy of the painting peaks, and the final details of completion appear. In Betty's case, the breakthrough of painting the paper black led to the breakthrough of the shaman, and then to the quantum leap breakthrough of the final details—the unexpected crowning touch of the skeletons dancing from the mouth. There's always an empty space in your painting, and if you stay with it long enough, a sudden flash of illumination will tell you exactly what must be there.

You can never stay with a painting too long. You can never paint too many layers, too many details, be too wild or aggressive. You do not always know what you're looking for. Nor do you necessarily know if there is anything left to discover. But if you have any doubt, any nagging question of completeness—even if it is as minuscule as the proverbial pea that tormented the princess through seven mattresses—

178

there is more to paint. If you do not feel completely and absolutely satisfied and awed by what you have done, you are not finished. Again, this does not mean that you have to enslave yourself to your first painting. Sometimes you have to begin many before you can truly complete one.

The transformational experience that results from pushing against your limits, from going "beyond your beyond," is always waiting, ready to happen. All you have to do is allow it by remaining patient, faithful, and present.

An apocryphal story about the great artist Michelangelo illuminates this point. One day, as he pushed a heavy slab of stone down the street, a neighbor asked why he was laboring so hard over a rock. "Because there is an angel in this rock that wants to come out," Michelangelo replied.

Each of has an inner angel, our individual destiny for this lifetime. Painting from the source will help you find yours by allowing this transformational aspect buried within you to be released. Perhaps you do not yet believe in your unique potential. This is because you have not yet known the bliss and the healing that occurs when you've allowed yourself to become a channel for and manifestation of source life. You haven't felt the ecstasy of bringing out the angel in the stone, your true self, in paint and paper. Painting from the source allows

this transformational aspect buried within you to emerge and be fully realized.

My next suggestion may strike you as paradoxical, but it's about maintaining a healthy balance. Take risks in your painting and test your limits in all that you do, but don't be arrogant about your limits. To play God/Goddess is to invite destruction. Like the mythical figure Icarus, we can fly too near the sun and get burned. Play like an innocent child, but when it comes to pushing through your blocks and resistance, respect your vulnerabilities. Be irresponsible and responsible at the same time.

Painting from the source has an exquisite built-in rightness to it, as if it's encoded with your own invisible genes that will activate in their proper time. Every event of your individual process happens when and how it should. All that really matters is that you've launched yourself onto a wonderful and rewarding lifelong adventure.

Whether your first adventures are a walk through fire, a trip to the stars, a tranquil stroll through the woods, or a little of everything, what really counts is your personal sense of accomplishment and that you are stirred deep inside. Whatever your experience or however your painting looks, please do not compare it to anyone else's or to some ideal standard: "I should have had the guts to expose my dark, primitive shadow like the book described [or like my painting partner

revealed], instead of just having fun making a rainbow tree." Again, it's the satisfying experience of painting what your heart dictates that counts.

The painting experience differs for each of us. Some of you will start slowly, but once you engage, you'll move quickly. Others will engage immediately, then hit a wall near the end of the process. There is no right or wrong way. Like kernels of corn, each of us pops in our own good, and appropriate, time.

Your first journey through this painting process will give you the experience and confidence for future voyages to the source. Though you may not be completely in the source flow after your first paintings, you have come close enough to know that it's possible. You may create a series of warm-up paintings before you reach the kind of breakthrough shift I've described, the one that will take you back to the source. And these experiences will stimulate and fortify your faith that your ability, patience, and magic are alive, well, and waiting within.

I want to emphasize once more the crucial element of faith. Have faith that the universe supports you, that a completion is there, waiting to be realized, and that it will happen if you hang in there long enough. Allow the search to take precedence over the discovery, and allow that search to be an exciting adventure.

Preserving Your Painting

When you and your painting are sure the process is complete, you may want to preserve it, because dried tempera can flake off over time. Apply a thin coat of clear acrylic varnish with a soft oval wash brush in gloss or semigloss finish, depending on how shiny you want the surface. The acrylic coating will bring back the shine your colors had when they were wet and will also smooth out wrinkles in the paper and help attached papers stay together. If the acrylic seems too thick or is in a gel form, thin it down with water, but not too much, as overly diluted acrylic may cause the colors to bleed. It's a good idea to try the acrylic on a test paper first, to get the hang of it. After you've finished applying a thin coat to your painting, wash the brush in warm water as quickly as possible to prevent a permanent film of dried acrylic from coating the hairs.

Once you go through a series of paintings, that is, a group of paintings that are closely connected in theme, like the chapters of a book, your painting process will become less self-conscious. The thoughts of your mind and the needs of your soul will begin to join and become simultaneous. You will not have to depend as much on fortuitous accidents or unconscious slips of the hand in order to

182

access your imaginative, poetic, and transformational content. You will be your true artist self, the one who follows his or her heart's desire to create, who values what's inside him or her enough to express it consistently, who is courageous enough to confront the blank sheet of paper (or the dance floor, the stage, the musical instrument, the word processor) in order to immerse him or herself in source energy, the creative flow that opens hearts. The English word *courage* comes from the French word for heart, *coeur*. Once you reconnect to your soul, or the source, you will live closer to your authentic, dream-making self. And every time you create from that inner wisdom, you encode source magic in your painting. Anyone who views your painting will relive the experience of its creator—your struggles to reconnect as well as your joy in becoming more whole.

Your Ongoing Connection to Your Source

Welcome home. You've returned to your creative roots, to your birthright, to awareness of your true self.

185

As painting becomes an integral part of your life, your footing on this creative path will become more and more sure.

Now it's time to absorb and assimilate your first painting experience and to bask in the energy of your painting, the record of your journey. Your next step will be to integrate this painting experience into your everyday life and to maintain and deepen your source connection.

Your Life Mirrors Your Painting

You may have slain a dragon or two in your quest to reclaim your creative spontaneity. These first breakthrough paintings are usually the most laborious, but they're also the most exciting and energizing. Their effect spills over into virtually every aspect of your life, making you more aware, accepting, confident, and eager to explore life's possibilities. Your future paintings may be just as riveting, but they will rarely require as much effort. You've been down the path; you have a sense of what to expect, and your psyche is already etched with the rudiments of the experience.

After my own breakthrough painting experience, I felt overwhelmed by its newness and strangeness, by its ecstasy and magic. I never imagined that there was more. I thought this had to have been a serendipitous accident that couldn't be repeated. To my delight

and surprise, I soon discovered that there was indeed more. In fact, the source is undepletable, and the more we tap into it, the more beneficial, profound, and transformative are its rewards. Every painting won't necessarily knock your socks off, but amid the ones that provide daily nourishment will be those that actually alter your life. For those of you whose first experience has been ecstatic, yes, nothing compares to that first-time thrill of triumphing over your fears and exploring your own mysteries. But the ease, expertise, security, and increased wisdom of your "mature" painting experiences will be more than a fair tradeoff. All it takes to deepen this process is regular painting sessions and your appreciation.

Don't worry if it takes you a while to resume painting after your first experience. Painting from the source is like riding a bicycle. Once you've learned how, you never completely forget. No matter how long you wait to begin your next painting, you will never lose all the ground you won from your first completion. The longer you do wait, though, the rustier your process becomes and the more it will take to get back in the flow. But a part of you has been transformed forever and will never be the same again.

How to Maintain Your Creative Source Connection

The most effective way to keep the source in your life is to continue painting, if only for half an hour a day or two hours a week. In the beginning, it's best to keep working on one painting until completion, even if you make only a single brushstroke a day. At times, you may not feel inspired. Just show up and paint for a minimum of fifteen minutes. If things start moving, stay with it. If not, try again later. Like that fisherman, your job is to put your line in the water and wait. Some days the river gives you a fish; other days it doesn't.

If painting regularly still seems impossible, here are some more ideas to keep you going:

◆ Keep making a painting schedule for yourself every week, even if you don't follow through perfectly.

◆ Make a date with another person. My painting buddy and I got together one Sunday a month. We'd send the kids to a baby-sitter and turn off the phone ringer.

◆ Join an Arts Anonymous or Artist's Way group.

◆ Have genuine contact with others who are involved with creative process work so you don't feel isolated and so they can nourish your process through cross-fertilization.

188

◆ View paintings, originals or copies, that move and excite you. Read books and poems, see movies, listen to music, and attend theater that attracts you and stirs the source within. Don't be surprised if your taste in these arts changes after your source exposure.

◆ If you are a person who habitually reads, attends movies, listens to music, or pursues other art/entertainment forms as a way to distract yourself from attending to your own inner creativity, then practice moderation in those activities.

◆ Spend time in places for which you have a natural affinity—the woods, the desert, the seashore, or the middle of a bustling city. Try to spend some time in the types of climates and settings that make your body comfortable.

◆ Ask for dreams each night to guide and inspire you. ◇

A Word to Trained Painters

Those of you who are trained in the arts may have found this approach to be a radical shift from your accustomed ways and style. Where do you go from here? How do you integrate painting from the source with the way you have painted professionally for years?

Professional painters who find their source paintings to be substantially different from the works they produced before have not necessarily changed their entire style, subject matter, and approach.

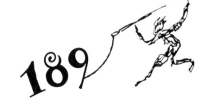

You change only as much as you need to, and, invariably, your painting is enhanced as a result. If you painted daily before you tried this method, you naturally will retain certain aspects of your individual style of expression, no matter how your process develops after this experience. For example, while painting from the source, an abstract painter may find herself producing realistic figures and scenes for the first time since childhood. Later, she might discover in her post-source paintings traces of recognizable figures, more risks, and a new depth of mystery. Or that personal imagery she discovered while painting from the source might evolve over time into more abstract forms that possess more power and resonance. A painter who normally works in the photo-realist style, portraying people in windowed exteriors or garden patio spaces, may find his source paintings filled with surreal dream fantasy creatures in exotic, otherworldly settings. When he returns to his usual style, he may discover that new, subtly risky elements have entered his paintings, such barely perceptible changes as pointed ears on an otherwise realistically rendered person—an alteration just beyond the possible that opens him and the viewer to a heightened vibration. Whatever your previous painting approach, it will be enhanced by the source connection as much and in whatever ways it needs.

In my own case, my many source paintings of women from every

 190

race and culture giving birth to all forms and varieties of life and my scenes peopled by serpents, trees, horses, and starry night skies seemed, on the surface, to be radically different from my previous large abstract expressionist landscape oils. But my source paintings retained the intuitive sense of color and contrast, the sensuous handling of paint, and passionate movement of my earlier paintings. After fifteen years of source painting, I can trace the progressive integration of my early colorful, abstract tree- and foliage-filled landscapes into my post-source archetypal birth and creation imagery, what I now call my visionary or prayer paintings. And mingled in along the way have been those necessary detoxification paintings that helped me resolve my personal health issues and emotional conflicts.

Care of Your Painting

Taking care of your painting, as you've probably realized by now, relates to your own emotional and spiritual tending. My breakthrough painting experience healed my ambivalence about my own creativity: needing to believe that I was the greatest at the same time that I was terrified at the prospect of facing my essential worthlessness. This ambivalence played out in how I cared for my paintings. When I began painting as a young girl, I was aware of the beauty and power of my art. But the more I fell in love with my paintings, the more undeserving,

191

fearful, and confused I felt. I had a vague sense of this dissonance, but I was basically unaware of its dynamics. On some level, I believed I didn't deserve to keep and enjoy anything I loved. I also believed that anything or anyone I loved or valued would be taken from me. Whenever I observed a painter, especially a woman painter, direct assistants to carry her heavy, carefully wrapped paintings with care and respect, I sneered at the display of love and pride, this treating of objects like precious children. Yet I'd also be overwhelmed with wonderment and envy that someone could feel such unconflicted self-respect. I'd console myself by pretending that I was superior because I cared so little about material objects. I was really devaluing *myself*.

How you care for your paintings after you've completed them and gone on to others says a great deal about how you regard the part of yourself that they express: your inner artist and creative child. How carefully you handle and protect your completed painting is analogous to how much you value your deeper self and how that self was treated by others when you were a child. Painters in my workshops often leave their completed paintings behind "accidentally," especially when the workshop is at my home. This seems to happen most often when the painting represents an aspect of themselves that they're not yet able to accept and live with. Others leave their paintings behind because, on some level, they believe that these vulnerable parts of themselves are

safer for now with me. These painters may not feel responsible or secure enough to care for their own vulnerable, newborn aspects. Of course, the reasons for these supposedly accidental forgettings are usually unconscious.

Taking careless risks with your paintings, particularly those you love, often reflects the lack of care and risks that were taken with you and/or your feelings as a child. I went through a number of "accidents" related to my inability to protect paintings I loved. One painting, a significant early painting of a magical naked woman on a winged horse, was thrown out in the trash by accident. Even though it was thrown away by my mother, it was my own carelessness that put my painting in harm's way. I had wrapped it in newspaper and left it lying around during one of my mother's throwing-away sprees. The real culprit in this story was my sense of unworthiness and my related beliefs that taking too much care was arrogant and that anything I really loved would be taken away from me anyway.

I was finally forced to confront that issue in a big way when a quantum leap painting infused with my entire heart and soul was left on a studio floor in New Mexico. I had the flu, so I asked a friend to store it for me until I could come back, even though I sensed that she was too distracted by her own concerns to remember. Of course, the painting was left behind and then thrown away by a maintenance worker.

Showing Your Painting

After completing your painting, you may feel like a new parent, and, like any proud parent, you may want to show off your little miracle. Just like a newborn, your painting needs to be shielded from harm. And, since the painting is also a visual expression of your deepest self, you are also in an extremely vulnerable state. You've worked hard to let go of the worst judgments of all—your own. All your progress could be eroded by a single thoughtless, insensitive remark, even one made by a dear friend who does not understand this process.

A neutral or cold response might reintroduce the same issue you fought so hard to resolve because you haven't yet acclimatized to your new inner reality. Your friend or relative may be open, sensitive, loving, and spiritually in tune, but he or she may not understand that you've just undergone a tumultuous journey and a profound opening.

It may take a while for others to understand what you're doing. Meanwhile, you and your painting need time to become grounded in the experience and for it to ripen within you. A friend or relative might admire an element in your painting if it had been painted by someone else. But that same element in *your* painting could force an unwelcome shift in his or her perception of you. Resistance to that change could

 214

easily be expressed by a negative remark or look. Two of my sons responded to my paintings of serpents birthing from women's vaginas with a resigned, "Well, that's mom." The third told me that he found the images disturbing. Their responses were understandable, and, luckily, I was grounded enough not to allow them to throw me off course.

Your painting may sing with authenticity and the profundity of universal myth and great art. Yet, it may be met, at the very least, with ambivalence, for so many possible reasons that it would take another book to analyze them fully.

Protect yourself and your first paintings by carefully selecting with whom you share them and when. This doesn't mean you shouldn't show your first painting to anyone. In fact, I encourage you to have at least one trusted person who has gone through the source painting process (or is aligned with a similar process) witness your painting. Sharing your painting with a safe other, whose responses are gentle and helpful, may awaken a new line of thought and direction about its meanings and gifts. The witnessing of your painting can concretize your experience, make it real. In other words, if another person sees it and recognizes its worth, the painting gains greater life, validity, and reality. Your experience moves from the realm of imagination, speculation, and "wasting your time" to a vibrant symbol of the spiritual core that

exists within you. Witnessing helps you take in the fact that all this really happened and that in the eyes of the source, your painting and your spirit are valuable, lovable, and worthy. Just as a newborn must be acknowledged, welcomed, and admired in order to thrive, you and your painting are validated by being ritually acknowledged and welcomed into your community or circle of painting friends. These paintings present a new you in a visual form that allows them to communicate and be shared, even if the sharing is just between you and your painting for now.

But if you persist in showing your early paintings despite consistently lukewarm or negative reactions, the question you should ask yourself is if a part of you enjoys shocking people or being misunderstood and victimized.

Of course, your integration process could include tearing up your painting and throwing it away, or using parts of it in another painting. You could also give your painting away, or even sell it. Just be aware of exactly what you are doing and why. Your goal is to be as aware as possible. If your painting represents something you feel ready to release—an issue or character trait you may have been holding onto like a marriage that ended ten years ago or an addiction you are working on—you can do a ritual burning as part of your soul retrieval. But do this only under the safest of circumstances, *please!*

Ask your painting to tell you what it wants. Before you destroy your painting prematurely, make sure you aren't acting from a pattern of self-sabotage.

Continue to Live with Your Painting

If it's at all possible, hang your painting on permanent display. (Again, be sure that your painting is not viewed by anyone who doesn't understand and appreciate your process.) The full relevance of all its images becomes apparent only after you've lived with your painting for a while. Long after your brush has stopped moving paint across its surface, your painting's vibrations will keep affecting you. These paintings are made in an altered state in which we can channel wisdom. They are filled with information that is fed to us like medicine from a time-release capsule, gradually and only when we are ready to accept it. Allow your painting to teach you. In the weeks that follow its completion, be open to painting any additions your painting may call for.

When I first began to paint in this way, my paintings, like my dreams, were about two years ahead of me. I would "wake up" from a painting or a dream unable to recognize its prophetic guidance for my life's direction. As I painted more and more and my self-awareness

grew, the gap between completion of a painting and my recognition of its deeper messages narrowed until, as will happen for you, execution and recognition became simultaneous.

Until that happens, keep your painting within view so you can receive its energy and message, *and* to reinforce your pride and self-respect. If it's not possible to hang your painting, find a safe place to store it and take it out periodically. Buy a portfolio to hold your paintings and make it special by decorating it with a painted symbol that means something to you. Those paintings too large for the portfolio can be rolled up and stored in a cylinder. If a painting is so large that it can't be rolled, cut it in half with a scissors or matte knife along a seam where two sheets are attached, so that they can be reattached easily when you take them out or simply hung next to each other. Take all the time you need to gaze at your painting and mine its riches—the wisdom, spiritual guidance, practical advice, and sense of discovery it gives you.

As you contemplate your painting in the days, weeks, and months following its completion, you may become aware of a deeper message lurking at its edges, or you may be overtaken by a sudden rush of comprehension, a spine-tickling "aha" that washes over you as every element comes together to make perfect sense. You may receive a vision of your life's progression in perfect clarity or be overwhelmed with

answers to life-altering questions. You may recognize a past issue that you had either "forgotten" or refused to deal with that is calling out for resolution and completion.

If you are still somewhat skeptical even though you've completed your first painting, these aftershocks of recognition and insight will help you accept the magic of your process and your spiritual connection.

One final, and reluctantly executed, image in an early painting of mine showed a dagger thrust into the neck of a spirited horse. I thought it represented a castrating aspect of my own nature. Then, more than a year later, I gazed at the painting with a friend who was viewing it with a fresh eye. I realized that the horse appeared decidedly happy, its head held high in unaffected pride. The dagger in his neck was not going *in* but coming *out*. It struck me that the dagger coming out of the horse was healing my traumatic tonsillectomy at age four, and that this goddess on her horse was a jolt of self-empowerment.

Every Element in Your Painting Is You

Your painting can have many layers of meaning, both personal and universal. You created that painting, so you are the ultimate authority on the meaning of its messages. This does not mean that you can't learn the rudiments of the universal symbolic language that you share with

all mankind. For example, a snake in a painting or dream is, first of all, simply a snake. It also carries many other possible meanings, depending upon its individual rendering, its context within the painting, its size, color, the number of times it appears, and your personal associations with snakes in general. Even so-called universal symbolism can differ wildly depending on the interpreter. In a book of Freudian interpretations, the snake would represent a penis. For some Native American tribes, it symbolizes transmutation. To fundamentalist Christians, the snake is temptation or evil. Buddhists and Hindus view the snake as a metaphor for rising kundalini energy or healing, and the snake appears in our Western culture as the symbol for medicine. Your own personal associations are probably limitless, and they are as valid, if not more so, than any generalized or universal associations. You will recognize the true messages of your images by the sense of knowing—the "aha"—that resonates within you at the moment of realization, like a musician's instantaneous knowing at the sound of a perfect chord. And, remember, when you sense the presence of more than one possible meaning, it is never a matter of one *or* the other interpretation, it is always one *and* the other(s). So the message of your painting is pure simplicity intertwined with fathomless complexity and mystery. Its ultimate message to you is to surrender and accept whatever you find there.

Tips for Witnessing Your Paintings

The following describes the closing ritual sharing in my workshops. If it is possible, try this with others or at least one other person.

◆ Stand from a vantage point where you can see the entire painting. Face it with your body, as if you were covered with sensitive eyes and could see your painting from every part of you.

◆ Ask yourself, "If this painting had sound, what would it sound like?" Make those sounds.

◆ If there are creatures, entities, animals, or people in the painting, make their sounds. Allow those sounds to come spontaneously and unselfconsciously from the source.

◆ If your painting or a particular image has a movement, what is it? Do it. Feel it.

◆ If any creature or any figure has come to this painting in order to say something, what is it saying? Stand in front of the figure and let its energy go through you in order to speak its message. Begin with, "I have come to say . . ." and let the figure complete the sentence. If there are others present, face them; make eye contact.

If I had wanted to explore the puzzling knife in the neck of the horse further, I would have "become the knife" and allowed it to speak from the context of that painting—improvisationally, with no time to plan.

201

Perhaps it would say the following: "I am the knife protruding from the proud horse's regal neck in Aviva's painting. I am steel-blue, with a jeweled handle. My sharp blade is frozen halfway in and halfway out of the neck. Blood drips from the horse's neck because of my presence, although the horse barely seems to notice me. It may appear that I've stabbed a fresh wound, but, in truth, I inflicted this painful but necessary injury a long time ago. I've been in this stallion's neck for many years. Now, the healing process is pushing me out. The small amount of blood you see is from the outward movement of my blade. Healing an original wound always involves shedding new blood. Now that I'm withdrawing, you, Aviva, will have more freedom of expression."

I wrote this without any preconceived notions on what the knife would say. You can do this too. Go as far as you want. I could ask the knife for more information about the wound, or I could apply what I've learned to what I already know about the painting in general and the issues that it reflects.

◆ Another way to explore a significant but persistently puzzling image is to begin another painting with an enlarged version of the image and see where it takes you. For example, I could have begun another painting with a close-up of the knife in the horse's neck and let the painting unfold from there.

202

◆ Is there a spot in your painting that you are tempted to touch? Touch it and pretend this spot is healing you. Follow any urge that arises.

◆ If people are present for your ritual sharing (and this is preferable), ask them to call out words that either describe your painting or are inspired by it: mysterious, joyous, eternal, exciting, peaceful, riotous. You can also ensure that you and your painting are received positively by asking viewers to keep their emotional reactions private or to limit their responses to simply saying your name, followed by "I see your painting." If you're alone, say the first words that come to mind, or, if you feel too self-conscious to speak them aloud, write the words in your journal. ◇

Early paintings often contain more personal material. Although a personal phase can take hold at any time, whenever it is needed, as your painting journey progresses it will naturally take on more universal themes and images.

Messages will come not only from your painting but from serendipitous events in your life and dreams that intersect with your paintings. You might meet an important person in your life who you suddenly realize was in your painting of a year ago. Events portrayed and predicted in your painting may also come to pass later.

The source experience is replete with myth and magic that we

tap into every time we paint. You may open a book or magazine that illustrates esoteric material you just happen to be painting. Over and over, I have witnessed the amazement and awe of these discoveries. When I was making my early source paintings, the right people always seemed to appear to witness them and validate my experience: "Oh, you painted Shiva," or "You painted kundalini energy." At that time, around fifteen years ago, I had never heard of Shiva or kundalini. The source wants you to have this knowledge corroboration. It wants to wake you up and give you faith in the magic of the universe and in your connection to it all, and it will use any means possible to do so. Earlier I told you about the intense painting I did which coincided with the spontaneous and complete remission of my arthritic symptoms. Interacting with me in that painting were three pointy headed troll-like creatures who I assumed were torturing me. Years later when by chance I showed this painting to a scholar in Native American mythology and healing lore, he exclaimed that I had painted the spirit guides who extract toxins from the body. Go figure!

Painting a Series

Even before you completed your first painting, you may have known how your next painting would begin. You may have already begun it. This next painting could be a completely separate and

self-contained experience, connected to your first painting like the chapters of a book are connected. Perhaps it is the beginning of a series of paintings joined by a theme, such as those of Picasso's Blue Period.

Of course, all your paintings are connected, because they are about you and your personal journey. As time goes on, though, you will come to recognize specific unifying patterns and themes. When I painted a Wild Women as Goddess series, I had no idea that was what I was doing. In retrospect, I realize that these paintings, and the dreams that I had around the same time period, had come to heal the feminine wound inflicted in me by my family, my religion, and my culture. They empowered and prepared me for my ongoing personal destiny as a painting medicine woman. Over time, you will discover that your paintings and your life are converging.

If you paint several paintings and become concerned about what you judge as a tendency toward one extreme—for instance, darkness, brooding, morbidity, and depression—don't be concerned. In time you will either tip in the opposite direction—paintings filled with light and sunny images—or you will progressively make your way toward a middle ground.

Sharing Your Paintings with the World

If our own culture was less dysfunctional regarding creativity, we wouldn't even have to broach this topic. You've worked hard to feel safe about releasing your creativity, to overcome the elitism and snobbery of the Western art world, and to feel that your creativity is valuable and essential to your life. You've worked hard to reconnect with the source of your creativity and your inner child and to allow your soul to manifest itself. So, I have to warn you that like sharing your paintings with friends, showing them publicly before you and they are ready could plant doubts about yourself and your process and cause you to lose ground.

Although you will know intuitively if and when to show publicly and which paintings are ready, some simple guidelines will help you understand the meaning of *ready* within this special context.

Just as the boundaries between painting as therapy, spiritual prayer, and art are fine and sometimes indistinct, so is the line that separates those paintings that are appropriate to share from those that are not. All authentic art reflects, at least in part, the painter's transformational experience in its creation. The painting offers a glimpse into the artist's soul and even bears elements of the therapeutic. But those early paintings can represent major cathartic detoxifications

that are more personal than universal in theme or subject matter, and they may not be appropriate for public viewing. They are necessary to your creative growth and healing—of body, mind, and soul—but they're usually best kept private.

The bottom line in deciding if you should go public and which paintings to show is not how profound or beautiful the painting is, but what is best for you and your painting. There is no right or wrong in this matter. Sometimes the painting itself is aching to be seen by the world, but the painter is not yet ready.

Slow down, have patience, listen to the painting and to your inner voice. If you feel that you do want to share your paintings with the world, wait a little while, at least until you feel absolutely grounded in your source connection and are confident in your vision and message. Wait until no criticism or negative response could possibly shake you from your course, because you are no longer influenced by the need for approval or praise from others.

Again, readiness and confidence to show your creations come only from regular painting. Little by little, painting by painting, you will become secure enough in your visions to withstand any public pressure and/or criticism. Putting your brush to paper regularly, and allowing each painting to follow the one before, brings the practical experience, healing, messages, mastery, purpose, balance, stability, and maturity

that you need before you can stand before the world. The act of painting itself will tell you how susceptible you are to fears of failure and/or fears of success.

When you *are* ready, show your paintings however and wherever possible—in galleries, shows, exhibits, installations, or reproduced on cards and posters. Go as public as possible. I encourage you to show your wildest paintings, as this world needs desperately to be shook out of complacency.

Moving to Expensive Archival Materials

Like a plant that outgrows its pot, eventually you may need transplantation to another medium. The question of whether and when to switch to more expensive archival media involves many of the same issues and cautions related to showing your paintings. Again, go slow, have patience, learn to respect your inner voice throughout the painting process, and be aware of all your options. Inexpensive tempera and paper counter inhibitions and performance anxiety. Wait until your imagery, freedom, confidence, and natural flow are so well-established that you can't lose any ground. Remember, all you really need to give permanence and luster to your tempera paintings is a thin, even coat of clear acrylic varnish.

Choice of medium is not unlike taste; you have to sample a bit first

before you know what you like. Some archival media you might want to explore include watercolors, gouache, acrylics, and oils. Drawing materials include pastels and oil pastels. A combination of any number of these media on pasted-together papers and/or other materials creates what is known as collage. Experiment and you'll be led to your personal choice of medium. As always, go with whatever your body tells you, not with what your mind prefers. Do you tend to use your tempera paint in watery, thin form, creating washes and drips? Do you enjoy dancing your brush lightly over the paper? Do you naturally gravitate toward open landscapes and luminescent, airy, translucent shades? Then watercolor might be your natural medium.

If you enjoy using tempera paint in a thick, layered style so that the paint almost sculpts itself, and you prefer that the paint dry quickly but with more shine and permanency, acrylic paint may be right for you.

Gouache is a more expensive, permanent, higher quality version of tempera that comes in tubes and is usually applied to a fine-grade watercolor paper. When dry, tempera is chalky, but gouache has luminescence. So if you're happy with tempera but would like to upgrade, try gouache.

Oil paint is in a category of its own. It is usually applied to stretched canvas, and, not surprisingly, is the most expensive choice. Turpentine is used to clean brushes instead of water, and linseed oil

is used to thin the paint. For those reasons, oil paint is far more toxic. But oil paint can also be built up into thick layers very quickly, though it takes days for even thin layers to dry. If you want to change an image, you have to scrape off the first layer of paint while it's still wet. So, if you want to use oils, your process must be relatively grounded and confident. When oil paint dries, it glows with a velvety texture and rich satin luster that is matched by no other medium. If and when you find your paintings organizing themselves as they flow out of you, and you don't mind the strong odor of the paints, turpentine, and linseed oil, you may fall in love with oil paint.

Take your time looking at paintings executed with these various media or page through an instruction book to see what appeals to you. Try each of them, and/or take a course in technique if you like. Let your progression into other media be natural. It's hard to err in the direction of staying with tempera too long, but it's easy to go off too soon to more expensive and complex materials. Again, your source connection should be well-grounded and your individual creativity firmly established before you switch.

Formal Training

Painters with no formal training have created extraordinary, magical paintings with depth and soul. Even the established Western art world recognizes the aesthetic and soulful power of such art. It used to be labeled *primitive*, *naif*, or *folk*, terms also applied to the works of indigenous peoples. Today's new labels are "outsider" or "visionary art." These artists include people who have made painting or sculpture their major activity and life focus, who paint and sculpt daily and sell like any trained professional painter, but who are self-taught and use cheap, found, and impermanent materials. As the term *outsider* implies, most of these painters are from cultures lacking the educational and exhibiting opportunities of cosmopolitan, middle-class society. In some cases, these painters may even be illiterate. But given the choice, many of them would refuse formal training, as they and the art world appreciate their paintings just as they are. Those of you who are not formally trained may also decide to remain self-taught, with only the source to guide you. You may believe that if you avoid art training, your work will remain pure and unspoiled, resistant to slick tricks and current fashion.

It doesn't have to be all or nothing. Once you are in touch with your source needs and voice, formal classes and instruction books

in drawing, life figure drawing, composition, media techniques, color, and draftsmanship can be helpful.

As I noted earlier, the ongoing source painting process itself will teach you skills. It will also make clear which areas of study attract you. Further training can complement your process by helping you build a creative vocabulary that allows your fullest expression. If human figures keep coming up in your paintings and those bodies seem to want more action, or, let's say, the hand and toe gestures are asking for assistance, explore your own body or join a figure drawing class with a live nude model. Your need to portray dramatic distance or a road, path, or river moving from the foreground to the background may prompt you to study the rudiments of perspective. If plants, trees, or certain animals keep appearing, study them from life, a book, or take a drawing course. Make sure that your natural need, curiosity, and the process itself leads you into more formal studies. Do not impose on yourself an arbitrary, "I should study this."

Once again, I urge you to let your paintings lead you to decisions, rather than following other people's advice or whatever is currently popular. Trust the process to tell you exactly what your soul needs, then to push you gently in the right direction.

All human beings are blessed with the natural urge to create and express themselves. Creative work keeps you close to your authentic emotions and makes you more expressive. The more you express yourself, the more content, enlivened, and conflict-free you become, and the more energy you can devote to even richer, more prolific creation. The courage to create and express freely is a coveted prize. That is why creativity is referred to as a gift and the creative person as someone who is gifted. Those who paint from the source understand that we are all gifted, and this knowledge is one of the greatest gifts you will receive from the source. Painting is a lifetime teacher that will guide you to your deepest, most satisfying expression.

In the end, your conscious understanding, insight, and integration of the painting into your life doesn't really matter. The painting process heals simply by happening through you. You may paint the resolution to a disease or problem you'll never even know you had. Complete and perfect intellectual understanding of all the layers of meaning encoded in your painting is impossible anyway, because our human understanding is limited. Discover the beauty of surrendering to this limitation and accepting that you will never know it all.

As you continue to paint, the boundaries between the paintings and your life will blur. The risks you take and the power you channel through your paintings will spill over into your life. You will become

aware of strange new dreams and a higher incidence of synchronous events. You will become your own greatest authority, and not in an ego-inflated sense. You will simply come to trust that your own inner voice is your best guide, and you will be more direct and outspoken. Your greater sense of personal freedom and spiritual connection will establish you as an artist-agent of healing change and enlightenment. Integrating the source into your life will keep you—and the world around you—balanced and sane.

Art Supply Catalogs That Support the Process

Cheap Joe's Art Stuff, Boone, NC, 800–227–2788. Wide selection and good prices for high-quality paintbrushes.

Pyramid Art Catalog, Division of Beckley Cardy Group, Mansfield, OH, 888–222–1332. Varied selection of tempera paints and paper and good prices. This catalog has a great section on visual art how-to books and videos. Also has books on how to make your own paper and art supplies.

Triarco, Arts and Crafts Incorporated, Plymouth, NH, 800–328–3360. Limited selection of tempera paint and paper sizes but slightly lower prices.

Schools That Support the Process

Expressive Arts Therapy and Spirituality

California Institute of Integral Studies (CHS), 415–674–5500, http:/www.ciis.edu. Graduate programs in psychology and somatics, Box CB, 9 Peter Yorke Way, San Francisco, CA 94109.

John F. Kennedy University, graduate programs in arts and consciousness, 510–254–0105, 360 Camino Pablo, Orinda, CA 94563.

Lesley College, 617–349–8300, 29 Everett St., Cambridge, MA 02138.

Naropa Institute, 303–546–3568, 2130 Arapahoe Ave., Boulder, CO 80302.

Southwestern College, certificate and graduate programs in art therapy and counseling, swclib@sfol.com, P.O. Box 4788, Santa Fe, NM 87502-5756.

University of Creation Spirituality, 510–835–4827, 2141 Broadway, Oakland, CA 94612.

Psychology and Spirituality

Institute of Transpersonal Psychology, 415–493–4430,
http://www.tmn.com/itp/index.html, 744 San Antonio, Palo Alto,
CA 94303

University of Santa Monica, Graduate programs in spiritual psychology and
counseling psychology, 310–829–7402.

Painting from the Source Workshops, Retreats, and Training Programs

P.O. Box 347, Ghent, NY 12075, 518–672–4410, aviva@capital.net,
http://www.avivagold.com/

Additional Therapeutic Help to Support the Process

Therapeutic

Directory of Gestalt Therapists, 914–691–7192

Directory of Holotropic BreathWork Practitioners (Rebirthing), 415–383–8779

Directory of Jungian Therapists, 212–867–8461

Directory for the Spiritual Emergency Network Therapists, 408–426–0902

Self-Help

Al-Anon, Virginia Beach, VA, 757–563–1600, 800–356–9996

Alcoholics Anonymous, General Service Office, New York, NY, 212–870–3400

Artist's Way groups: Inquire at your local Arts Anonymous group or new
age recovery bookstore. Better yet, be the first to start a Painting from
the Source group in your town.

Arts Anonymous, New York, NY, 212–873–7075

Co-Dependents Anonymous, Phoenix, AZ, 602–277–7991

Debtors Anonymous, New York, NY, 212–642–8220

Gamblers Anonymous, Los Angeles, CA, 213–386–8789

Narcotics Anonymous, Canoga Park, CA, 818–773–9999

Sex and Love Addicts Anonymous, West Newton, MA, 617–332–1845

Survivors of Incest Anonymous, Baltimore, MD, 301–282–3400

Books for Creative Inspiration Support

Art and Soul: Notes on Creating, by Audrey Flack, Viking Penguin, 1991.

Artist's Way: A Spiritual Path to Higher Creativity, by Julia M. Cameron, Putnam Publishing Group, New York, 1995–97.

Artists of the Spirit: New Prophets in Art and Mysticism, by Mary C. Nelson, Brotherhood of Life, Inc., 1994.

The Blank Canvas: Inviting the Muse, by Anna Held Audette, Shambhala Publications, Boston, 1993.

The Courage to Create, by Rollo May, W. W. Norton, New York, 1975.

The Eighth Day of Creation—Gifts and Creativity, by Elizabeth O' Connor, Word Books, Waco, Tex., 1971.

Free Play: The Power of Improvisation in Life and Art, by Stephen Nochmanovitch, Jeremy P. Tarcher, Los Angeles, 1991.

Freeing the Creative Spirit: Drawing on the Power of Art, by Adrianna Diaz, Harper San Francisco, 1992.

Higher Creativity: Liberating the Unconscious for Breakthrough, by Willis Harmon and Howard Rheinhold, Jeremy P. Tarcher, Los Angeles, 1984.

Learning by Heart: Teachings to Free the Creative Spirit, by Corita Kent and Jan Steward, Bantam Books, New York, 1992.

Living Color: A Writer Paints Her World, by Natalie Goldberg, Bantam Books, Inc., New York, 1997.

The Mother's Songs: Images of God the Mother, by Meinrad Craighead, Paulist Press, New York, 1985.

No More Second Hand Art: Awakening the Artist Within, by Peter London, Shambhala Publications, Boston, 1989.

Original Blessing, by Mathew Fox, Bear and Co., Santa Fe, 1983.

The Re-enchantment of Art, by Suzie Gablik, Thames & Hudson, New York, 1992.

Vein of Gold, by Julia M. Cameron, Putnam Publishing, New York, 1996.

Waking Up in the Age of Creativity, by Lois Robbin, Bear and Co., Santa Fe, 1985.

The Woman's Book of Creativity, by C. Diane Ealy, Beyond Words Publications, Hillsboro, Ore., 1995.

Books for Visual Art Support

Drawing on the Artist Within: An Inspirational and Practical Guide, by Betty Edwards, Simon & Schuster, New York, 1987.

Drawing on the Right Side of the Brain, by Betty Edwards, Jeremy P. Tarcher, Inc., Los Angeles, 1989.

Life, Paint & Passion: Reclaiming the Magic of Spontaneous Expression, by Mitchell Cassou and Stewart Cubley, Putnam Berkley, New York, 1995–96.

Mandala: Luminous Symbols for Healing and *Drawing From the Light Within*, by Judith Cornell, Theosophical Publication House, 1994.

Painter's Quest: Art as a Way of Revelation, by Peter Rogers, Sigo Press, 1994.

Zen Seeing, Zen Drawing, by Frederick Franck, Bantam Books, New York, 1993.

Other Books That Support the Process

General

Beyond the Brain: Birth, Death and Transcendence in Psychotherapy, by Stanislov Groff, State University of New York, Albany, 1985.

The Blooming of a Lotus: Guided Meditation Exercises for Healing & Transformation, by Thich Nhat Hahn, Beacon Press, Boston, 1993.

Blue Fire: Selected Writings, by James Hillman, HarperPerennial, New York, 1989.

Care of the Soul, by Thomas Moore, HarperCollins, 1992.

Maya Angelou: Poems, by Maya Angelou, Bantam Books.

One Year to Live: How to Live This Year as If It Was Your Last, by Stephen Levine, Beacon Press, Boston, 1997.

Seat of the Soul, by Gary Zukav, Shambhala Publications, Boston, 1991.

The Tibetan Book of Living and Dying, by Rimpoche Sogyal, Harper San Francisco.

The Road Less Traveled, by M. Scott Peck, Simon & Schuster, 1978.

The Tao of Physics, by Fritjof Capra, Simon & Schuster, 1990.

Women Who Run with the Wolves: Myths and Stories of the Wild Woman Archetype, by Clarissa Pinkola Estés, Ballantine, New York, 1992.

Writing Down the Bones, by Natalie Goldberg, Shambhala Publications, Boston, 1986.

Dreams

Conscious Dreaming, by Robert Moss, Random House, New York, 1996.

Dreamscape: Creating New Realities to Transform & Heal Your Life, by Nicholas Heyneman, Simon & Schuster, 1996.

The Dream Game, by Ann Faraday, Harper & Row, New York, 1974.

Expressive Arts Therapy

Art as Medicine: Creating a Therapy of the Imagination, by Shaun McNiff, Shambhala Publications, Boston, 1992.

Queen's Quest: Pilgrimage for Individuation, by Edith Wallace, Moon Bear Press, 1990.

A Jungian Perspective

The Creative Connection: Expressive Arts as Healing, by Natalie Rogers, Science and Behavior Books, 1993.

Ritual

Ritual, Power, Healing and Community, by Malidoma Somé, Swan Raven and Company, 1993.

Serving Fire: Food for Thought, Body and Soul, by Anne Scott, Celestial Arts Publishing, Berkeley, Calif., 1994.

Spiral Dance, by Starhawk, HarperCollins, New York, 1989.

Alternative Health

Homeopathy: Medicine of the New Man, by George Vithoulkas, Simon & Schuster, New York, 1985.

Kundalini Rising: Mastering Creative Energies, by Barbara Condron, S.O.M. Publishing, 1992.

What Really Is Behind Loss, Disease and Life's Major Hurts, by Meredith L. Youngs, Sowers Press.

Guidebooks for Retreats and Healing Centers That Support the Process

Artists & Writers Colonies: Retreats, Residencies & Respites for the Creative Mind, by Gail H. Bowler, Blue Heron Press, Hillsboro, Ore., 1995.

Natural Healing Centers of America, edited by Streimer Glen, Mountain Missionary Press.

Transformative Adventures, Vacations and Retreats: An International Directory of 330 + Host Organizations, by John Benson, New Millennium Publishing, 1994.

Transformative Getaways: For Spiritual Growth, Self-Discovery & Holistic Healing, by John Benson, Henry Holt, New York, 1996.